I0599791

BESTIARY

ANIMALS IN ART FROM
THE ICE AGE TO OUR AGE

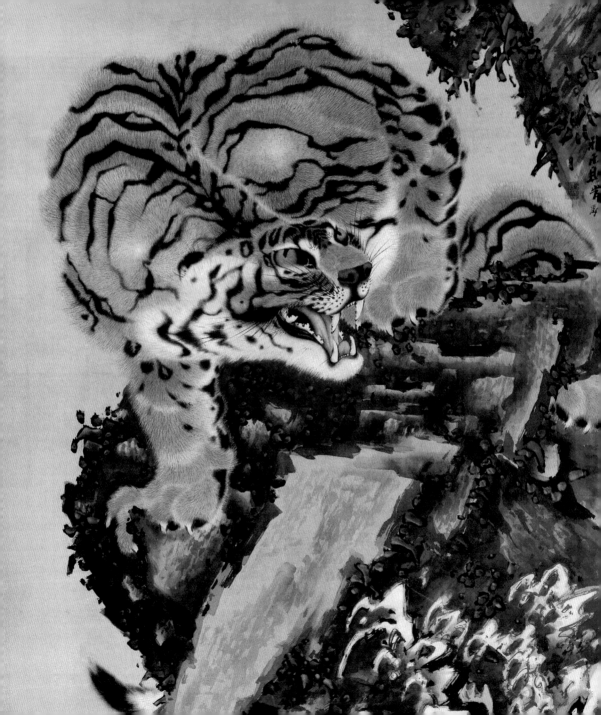

BESTIARY

ANIMALS IN ART FROM
THE ICE AGE TO OUR AGE

CHRISTOPHER MASTERS

WITH 268 ILLUSTRATIONS

Thames & Hudson The British Museum

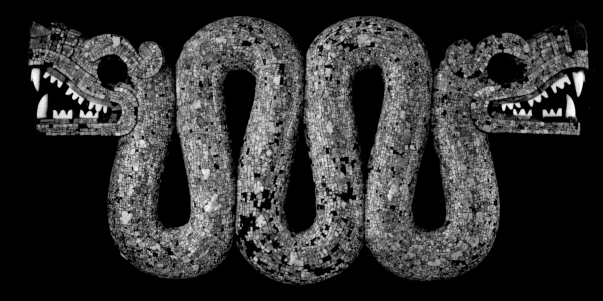

CONTENTS

Introduction

EYELESS, ZHANG SENGYOU'S dragons remained utterly still, locked to the temple wall on which they were painted. But when, at the insistence of his public, the artist gave two of them their vision, they sprang out of the image and flew away. So he left the others as they were.

The story perhaps relates less to monsters and their habits than to the reputation enjoyed by this legendary artist (fl. *c.* AD 490–540), and the superstitions and taboos of his time. But it also expresses the qualities that we as viewers have required from art, not just in ancient China but arguably through the centuries up to our own day. We want art to be as vivid and engaging as any Chinese painting or ceramic, provided it is also motionless or supine and, preferably, dead. The eyes may blaze, but they must be blind. This passive quality is most obvious

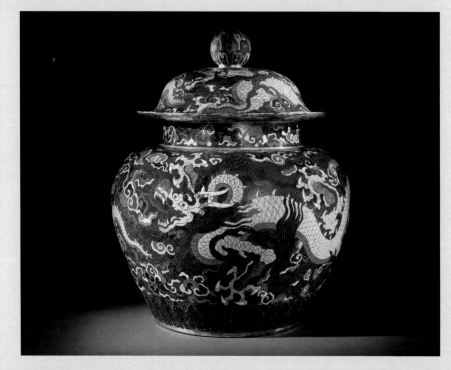

Cloisonné jar and cover
with dragons
Ming dynasty, 1426–35
Beijing, China
Metal, enamel
H 62 cm, W 55.9 cm

when the artefact is in a museum cabinet or on the pages of a book, which we peruse at our leisure in a way that is impossible anywhere else, least of all in the natural world.

If there is one subject that art most usefully pacifies, it is the animal kingdom. This book is full of creatures, both real and imaginary, that in the flesh would bite, burn or simply bolt. Even beasts that we have, at least theoretically, brought under human command can be examined more easily when translated into images such as Dürer's marvellous drawing of the muzzle of an ox. This watercolour may have been intended as a study for the background of the engraving *Adam and Eve* (page 140), but its treatment of fur and flesh is far more precise than in the print, and it can be enjoyed as a work of art in its own right.

While Dürer was famously zealous about his status as an artist, many of the objects here are from cultures that did not have a concept of 'art', at least not for its own sake. Most of the ancient Egyptian images, for example, were accessories to religious observance and belief. The model oxen on page 77 are as static as Dürer's beast, but were in fact supposed to burst into life and serve the owner of the tomb in which they were found in his idyllic afterlife. These terracotta figures have a utilitarian air, but many Egyptian sculptures are exquisitely proportioned

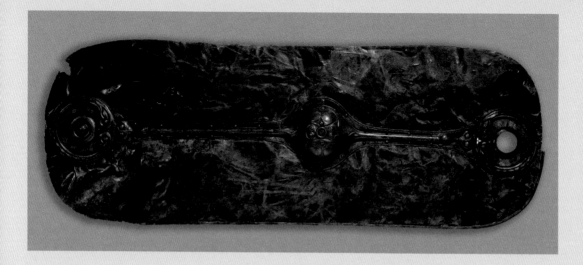

and executed, so that we more easily appreciate them as 'art'. Yet these aesthetic qualities were so inextricable from their sacred significance that they would undoubtedly have been appreciated in a profoundly different way from a modern artwork. The bovine-headed goddess Hathor also tells us much about the Egyptians' concept of nature, which was intertwined with both the human and divine worlds in ways that we can hardly imagine in our secular, urban reality, encompassing as she did aspects of motherhood, love, beauty and, on occasion, feminine wrath.

Pre-modern societies did not make a hard distinction between 'natural' and 'supernatural' in the way that we do today, and the veneration of animal spirits and divinities took many forms. Hybrid creatures, outlandish combinations of the human and the bestial, appeared in a wide range of cultures, and their functions were equally varied. The horses on the Iron Age Aylesford bucket, for example, have knees and feet that make them look like humans dressed as horses rather than real animals. These dancing figures might represent part of a religious rite, shamanic dance, or even a parade or performance designed to entertain.

The perceived spiritual potency of certain animals is vividly recorded by another Iron Age object, the Witham shield. Its face displays the outline of a

The Witham shield
c. 400–300 BC
Witham, England
Copper alloy and coral
L 109.22 cm, W 34.5 cm

BELOW
The Aylesford bucket
c. 75–25 BC
Found in Aylesford, England
Wood, iron and copper alloy
H 34.5 cm, Diam 29 cm

BELOW, RIGHT
The Basse-Yutz flagons
c. 420–360 BC
Found in Basse-Yutz, France
Copper alloy, coral and glass
H 39.6 cm

boar, perhaps originally affixed in leather or metal. The image of this formidable animal might have been intended to lend its protection to the warrior who wielded the shield. Although the boar itself is now lost, stylized faces of cows or horses also appear, together with swirling designs that may represent water birds. The fact that so many animals are combined, and in some cases almost concealed, within this object reflects the omnipresence of nature in the experience of people in Britain over 2,000 years ago.

In contrast to the abstraction of the shield's decoration, the dogs on the handle of the Basse-Yutz flagon are influenced by more naturalistic Greek and Etruscan images. Together with the inimitable duck on the spout, they show how the artists of Celtic Europe expressed their relationship with animals through an extremely broad range of motifs.

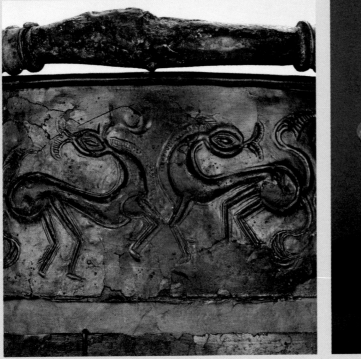

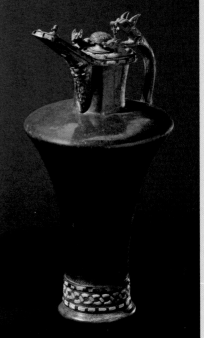

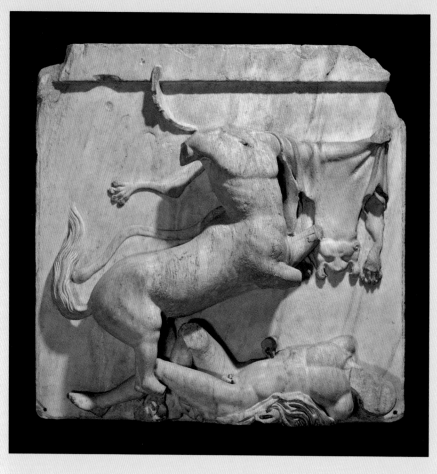

Death of a Lapith
Greek, c. 447–438 BC
From the South Metope
XXVIII of the Parthenon,
Athens, Greece
Marble
H 134.5 cm, W 134.5 cm

'A thousand turbid streams, pouring into Hellas from every side, issued thence grandly, in a calm and transparent river, to fertilise the world. So it was with the Sirens.' In his masterpiece *Siren Land*, the English author Norman Douglas imaginatively described how the Greeks turned the flesh-eating Sirens of Near Eastern mythology into creators of bewitching song (see pages 216–19), if still not exactly paragons of virtue. A similar process was undergone by centaurs, who may have been inspired by Greek encounters with Scythian horsemen but probably were first imagined by the Babylonians. Anyone who consults the

zodiac, which means 'circle of animals' in Greek but is a Babylonian invention, should know that Sagittarius is a centaur. In the hands of the sculptors of the Parthenon in Athens, centaurs became models of human anatomy transposed onto magnificent stallions; they were in turn adopted by the Romans.

However, for all their classical aestheticism, as hybrid creatures the centaurs had an ambiguous moral identity. While Sagittarius and another constellation, Centaurus, are sometimes identified with the noble Chiron, who taught the Greek hero Achilles, the Parthenon's centaurs evoked rival cultures such as the 'barbarian' Persians, who had destroyed an earlier temple on the Acropolis. In Roman sarcophagi, centaurs are often shown partaking in scenes of drunken revelry, albeit loaded with symbolism of the afterlife, and accompanied by the god Pan, a figure with goat-like haunches, legs and horns, and attendant satyrs. Of all the major Greek and Roman gods only Pan, who was associated with fertility, hunting and the pastoral world, was endowed with animal features. Otherwise, the classical pantheon was mostly anthropomorphic, as if to emphasize the secondary role of animals in the divine scheme.

It is tempting to see these classical cultures as initiating the divorce between man and nature that we experience today, a process accelerated by a host of other factors, from the spread of the Judaeo-Christian concept of God to the triumph of urban life and, eventually, industrialization. In Western cultures, animals have remained significant as economic commodities, objects of wonder and companions, but they have often ceased to be venerated or even treated with much respect.

Sarcophagus depicting
the marriage procession
of Bacchus and Ariadne
Roman, 2nd century AD
Made in Rome, Italy
Marble
H 53.5 cm, W 219.5 cm

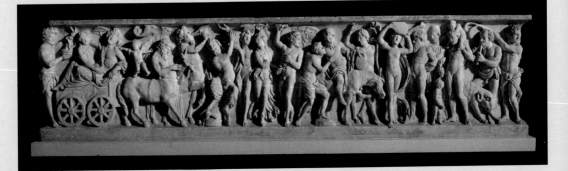

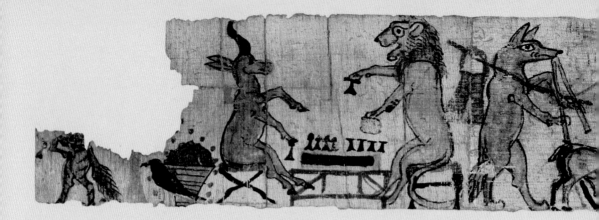

The same is not true worldwide. A different, equally complicated story is told by images from other cultures, such as the 19th-century bronze Kangiten (page 211), a Japanese divinity derived from the Hindu god Ganesha and associated with financial success. If the collection of objects gathered in this book demonstrates anything, it is the impossibility of making too bold generalizations about any particular period or, for that matter, culture. How can we emphatically celebrate the rational humanism of classical antiquity when we know that Roman houses were guarded by *tintinnabula*, winged lion-phalluses that tinkled like bells in the wind? And surely piety is not the dominant quality of an Egyptian satirical papyrus in which one gazelle plays a board game, another copulates with a lion, and a variety of animals perform human duties similarly antithetical to their nature.

The depictions of animals throughout this book reflect fundamental developments that have taken place over time, and around the globe, in the relationship between humanity and the natural world. However, as our themes show, there are remarkable links to be made between images from wholly different cultures and periods, as well as sharp distinctions within civilizations. These themes produce some surprising and memorable analogies and juxtapositions: an Aztec rattlesnake and a Benin python (pages 60–61): a Pictish carving of a bull and an ox-shaped snuff box made by the Xhosa people in South Africa (pages 178–79); or a French luxury ewer in the form of a sea monster next

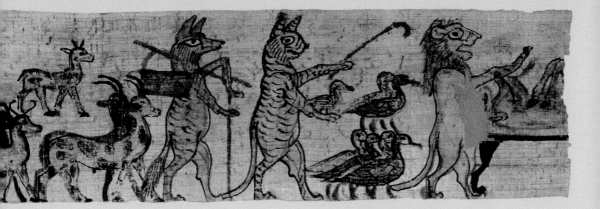

Papyrus with satirical
vignettes
c. 1250–1150 BC
Deir el-Medina, Thebes,
Egypt
Painted papyrus
H 13 cm, W 59 cm

to a Flemish political print of *The big fish eat the little fish* (pages 244–45). Some
objects could happily appear in more than one section, such is the richness of
their imagery and context. One of the best ways to read this book is occasionally
to break out of its structure, to create new connections and qualify existing ones.

An array of such evocative artefacts will surely stimulate everyone's sensibility.
A fascination, and even love, for animals is a feeling that most of us experience
as children. For many it persists into adulthood, stimulating the imagination in ways
that we do not always understand. I hope that for some at least of this book's
readers, the dragons will stir and take wing, as they did for Zhang Sengyou
1,500 years ago. Is this not perhaps what we want from art after all?

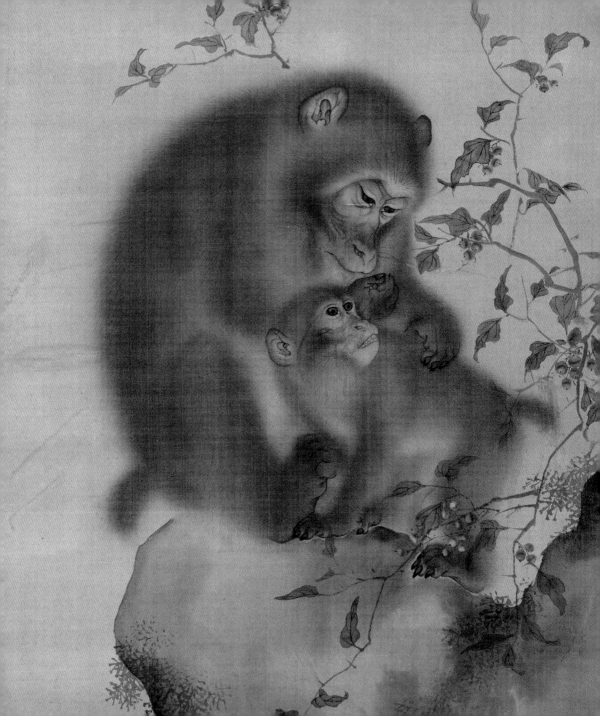

—1—
ANIMALS OF THE WILD

WHEN HUMAN BEINGS REPRESENT animals and the natural world, they often transform what they see. The 17th-century Japanese painter of the Tanzan shrine depicted wild geese in a landscape awash with gold leaf, as if to transpose the profusion of nature into richness of another kind (pages 52–53). Yet, for all the painting's lavish artifice, the animals themselves remain remarkably real and present. One can almost hear their honking or feel the cold against which one of them huddles, asleep.

In this case the expression of empathy is the product of a sophisticated urban society, in which the artist probably had no practical connection with his subject. How different was the experience of an Ice Age hunter, creating objects that were connected with life-or-death activities! The horse engraved on a bone (page 18) is as vivid as the geese from Japan, yet a gulf separates the functions of the two objects, and the contexts in which they were made.

It is remarkable how the response to animals can seem so constant in artefacts of different periods and cultures, despite the immense changes that have taken place in the physical relationship between humans and animals. Long after the development of agriculture, settled societies preserved the excitement of the hunt, as can be seen in the Assyrian reliefs displaying the slaughter of lions (pages 26–27). In Assyria, however, the hunts had become aristocratic activities, part sport and part ritual affirming the religious and political status of the king.

Such images invariably present the beasts as the *other*, something entirely alien. Yet animals in art are often given anthropomorphic qualities. The bunnies in a Beatrix Potter story are lavished with the affection bestowed upon a domestic pet, blurring the division between the wild and the domestic (page 44). Even more striking are the depictions of monkeys, from a range of societies, that explore the links between humans and some of our closest relatives (pages 40–43). They exemplify how representations of wild animals can, in a variety of ways, give us profound insights into our own psyche.

Assyrian reliefs depicting scenes from the royal lion hunt (detail)
See pages 26–27

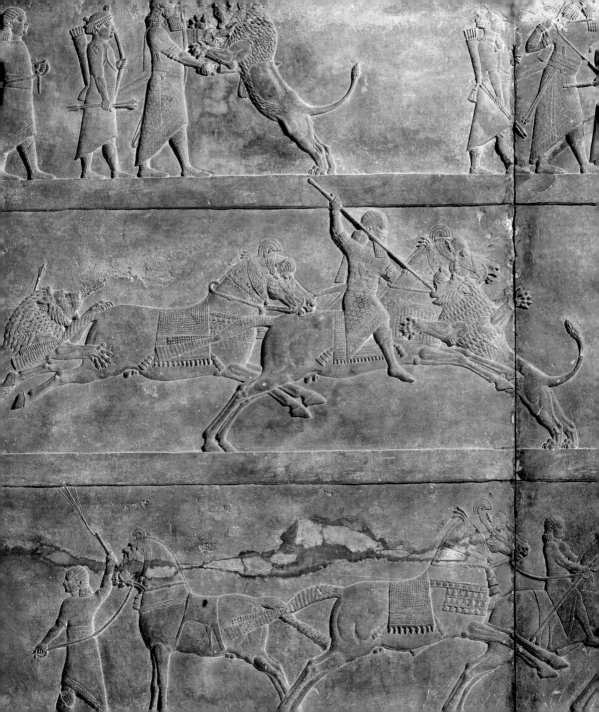

Hunting for Survival

Hunting is humankind's oldest occupation, originally an essential source of food rather than the leisure activity of society's elites. The horse is now a largely domesticated creature, but 12,500 years ago large, wild herds were the prey of hunters rather than their accessory. Upon the engraved rib bone known as the Cresswell Horse, a wiry profile of a horse with a spiky mane apparently passes behind vertical posts or spears as it is driven to its death.

Engraved drawing of a horse
This is the oldest known work of art from England
From Robin Hood Cave, Creswell Crags
Bone
L 7.3 cm

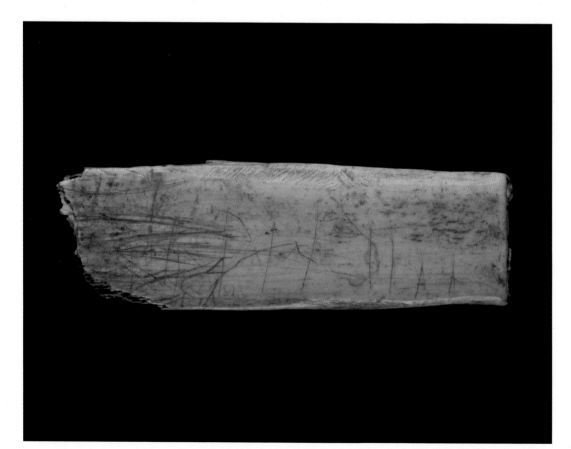

Hooked end of a weighted
spear-thrower sculpted
as a mammoth
c. 13,000 years old
From Montastruc, France
Reindeer antler
L 12.4 cm

Unlike the Cresswell Horse, this spear-thrower
represents an extinct animal: a mammoth, with tusks
and a trunk. It is made from the antler of a reindeer,
with an eyehole that was once probably inlaid with
stone or bone. Although not in perfect condition, this
artefact is a remarkable survivor of Ice Age culture.

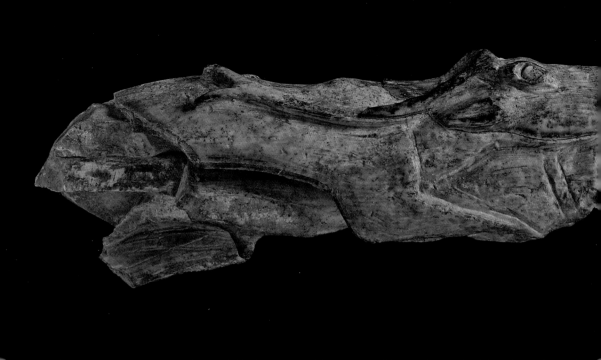

This vivid, incised depiction of reindeer swimming may represent an episode from a hunt. Certainly, the animal was an important source of food and fur in prehistoric Europe, and this image could be an attempt to gain mastery over the creature through its representation.

The engraved antler gives the impression of having a similar function, but is in fact a relatively modern object, probably made for the tourist market. In northern Scandinavia, reindeer have been semi-domesticated and herded for centuries by the Sámi peoples, but this image satisfies outsiders' conceptions of the wildness of Arctic life.

ABOVE
The Swimming Reindeer
At least 13,000 years old
Found at Montastruc, France
Mammoth ivory
L 22 cm

OPPOSITE
Decorated reindeer antler with incised decoration possibly by the Sámi people of Nordic Europe
Early 1900s
Northern Europe (Norway, Sweden or Finland)
Reindeer antler
L 46.8 cm

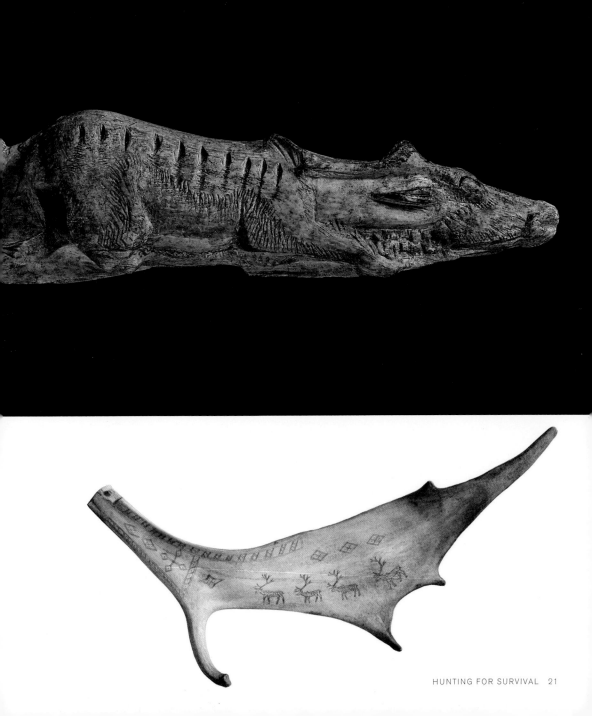

The Blackfoot people, who are from the arid grasslands of the northern United States and Canada, began to acquire both firearms and horses, originally introduced by Europeans, in the 18th century. This image represents a Blackfoot, recognizable from his leggings, riding a horse but using traditional weapons to hunt bison. It represents a way of life that was coming to an end by the late 19th century, as settlers from the east pushed into Native American territory.

Whaling remains vital to the cultural identity of Pacific Northwest Coast indigenous societies, even though it is now restricted to occasional hunts by the Makah people, who live in the American state of Washington. This cedar-bark hat, made by a member of the Nuu-chah-nulth from the west coast of Vancouver Island, vividly conveys the excitement of hunting from canoes with harpoons. The mythical Thunderbird is said to have taught whaling to the ancestors of these peoples, who hold the bravery and physical endurance that it involves in high esteem.

BELOW
Bison Hunting
c. 1890
North America
Watercolour
H 24.8 cm, W 37.7 cm

OPPOSITE
Whaler's hat
Made by Cecilia Savey,
Nuu-chah-nulth
1981
Vancouver Island, Canada
Spruce root, cedar bark fibre
H 27 cm, Diam 28 cm

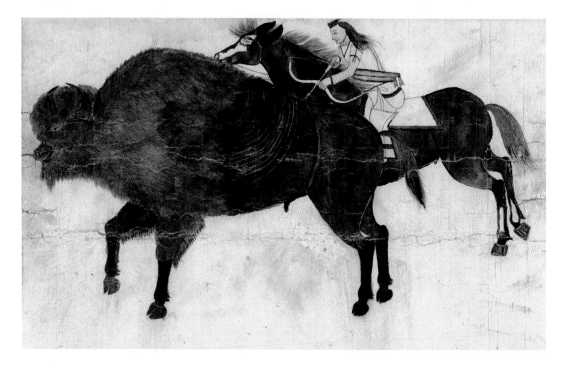

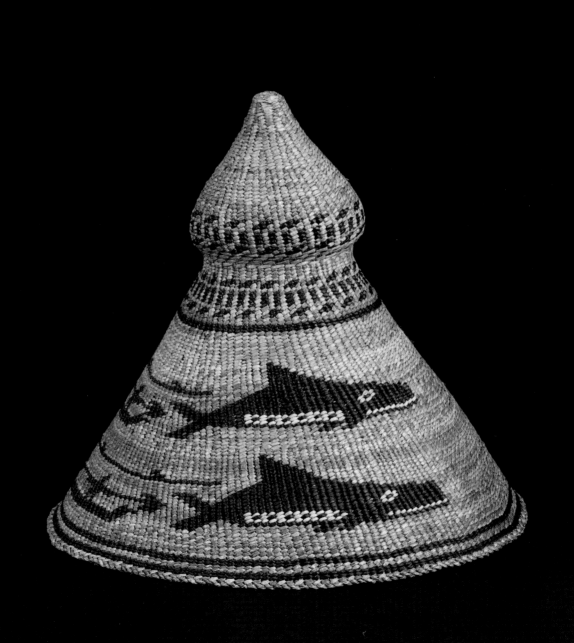

The Hunt as Ritual and Sport

Accountancy has never looked so exciting. In this mural Nebamun, an Egyptian temple 'scribe and counter of grain', is shown striding into the marshes beside the Nile. A multitude of fish and a lone wildcat can be seen nearby. As the ducks and other fowl fly up in front of him, he grasps three birds in one hand. While this tomb painting contains religious symbolism associated with rebirth, it is also a triumphant image of man's domination of the natural world.

The mural contrasts with the more hieratic image of a male divinity found on the island of Aegina and showing wider Eastern Mediterranean influences. Here the lotus flowers and boat-like structure beneath the figure's feet also suggest an aquatic setting. The curved forms, perhaps bull's horns, and the captured geese signify the forces of nature, from whose mastery the god derives his power.

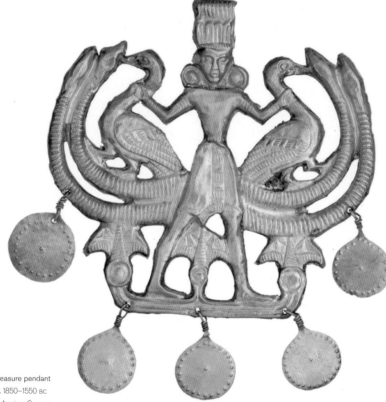

ABOVE
Aegina Treasure pendant
Minoan, c. 1850–1550 BC
Found on Aegina, Greece
Gold
H 6 cm

OPPOSITE
Tomb painting representing
Nebamun hunting and fishing
18th Dynasty, c. 1350 BC
Thebes, Egypt
Polychrome painted plaster
H 98 cm, W 115 cm

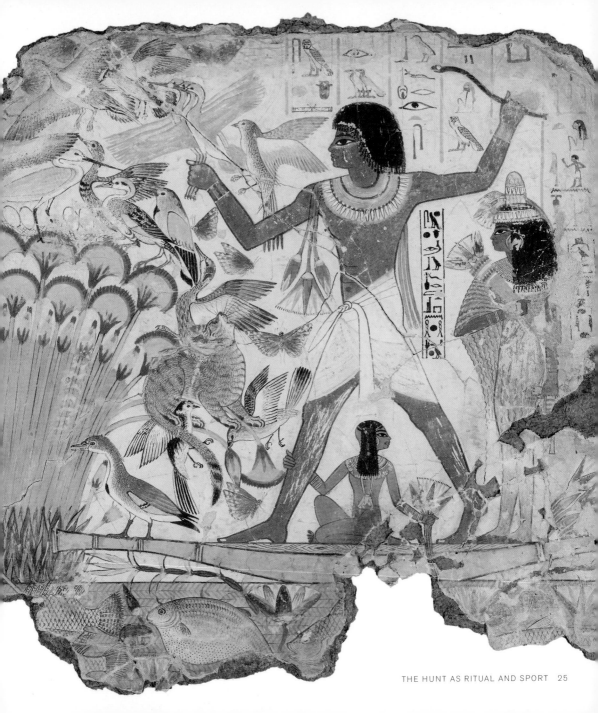

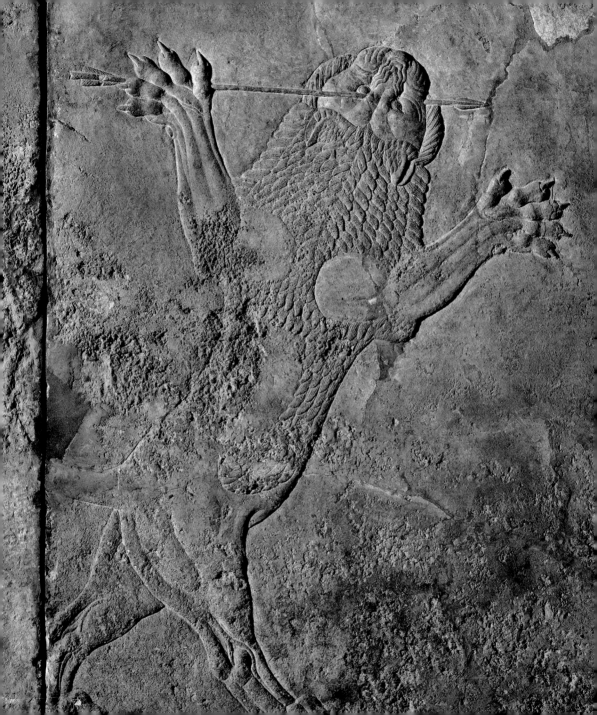

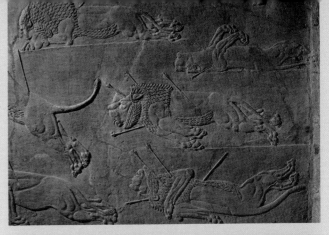

The lion hunt in King Ashurbanipal's palace at Nineveh is the most remarkable of Assyrian sculptures. Injured, dead or dying animals seem almost to float on the surface of the relief, breaking out of the strict horizontal format that dominates so many sculptures of this period. The anatomies and poses of both hunter and hunted convincingly represent this form of royal entertainment, which may have been accompanied by religious ceremonies enhancing the authority of the king.

In one section of the composition a particularly revealing detail can be seen. The savage beasts are not being hunted on the open plain but are released by young boys from their cages into an enclosure. As is clear from the response of the lions, they have been captured, but not domesticated.

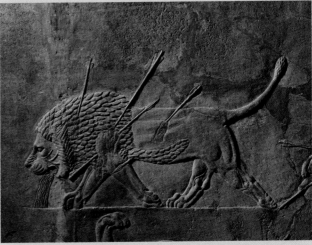

THESE PAGES
**Assyrian reliefs depicting scenes
from the royal lion hunt**
c. 645–635 BC
From the North Palace
at Nineveh, Iraq
Gypsum

OPPOSITE
H 160 cm, W 109.2 cm

RIGHT, TOP
H 162.6 cm, W 172.2 cm

RIGHT, MIDDLE
H 157.5 cm, W 127 cm

RIGHT, BOTTOM
H c. 165.1 cm, W c. 121.9 cm

Leopards were hunted and killed as part of court ritual in the West African kingdom of Benin. The plaque illustrated here is a triumphant figure of the ruler, or Oba, holding up the dead creatures. The two mud fish hanging from his belt associate him with Olokun, god of the great waters and of earthly wealth.

In the Egyptian tent hanging, lions are represented alive but chained to a tree. With their strikingly human faces, they may have been regarded as protective figures. This iconography, sometimes showing the lions holding swords, is repeated in marriage chests or above doorways, while the canopy here would have been used during religious ceremonies and festivals. The inscription at the top reads: 'There is no victory except from God.'

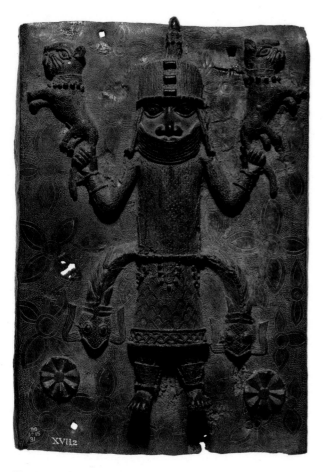

LEFT
Benin plaque showing an Oba (king) holding two leopards
c. 1500–1600
Benin City, Nigeria
Brass
H 43.5 cm, W 41 cm

OPPOSITE
Appliqué tent hanging
Mid-1900s
Egypt
Cotton on canvas
H 260 cm, W 170 cm

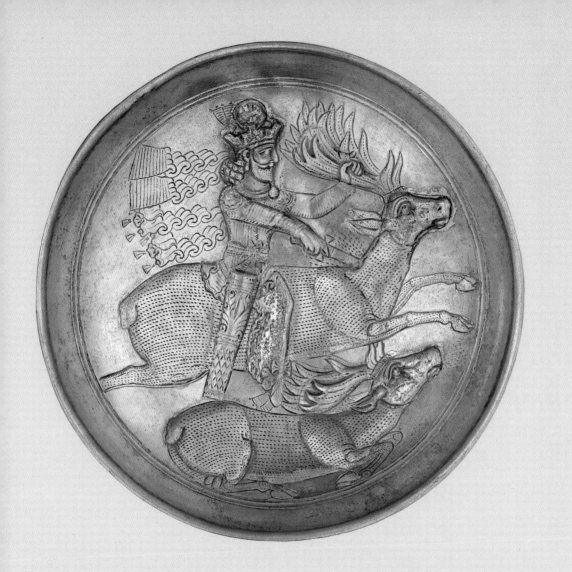

This ceramic from the Moche culture in pre-Columbian South America depicts an animal that was crucial to the society's religious life. For the Moche, hunting deer was a rite inextricably linked to human sacrifice, while in other cultures it was a courtly pastime that also had a theological significance.

The plate representing the powerful Iranian ruler Shapur II, who greatly expanded the Sasanian empire, dramatizes an essential belief of the Zoroastrian faith: the primacy of the conflict between good and evil, and order and chaos. This principle is symbolized by the struggle of the hunter with his quarry, which he is actually riding as he plunges his sword.

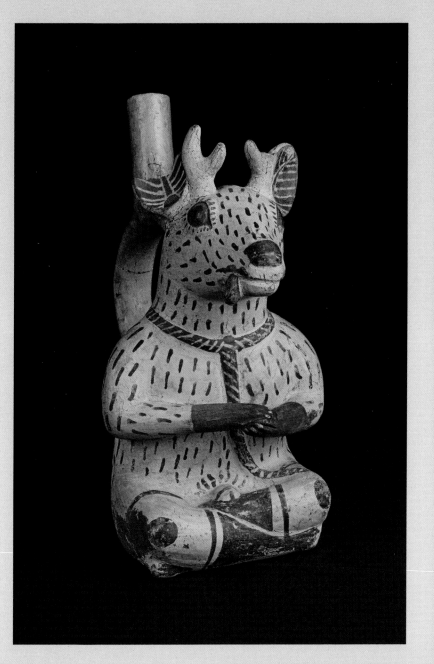

Hunting also often had romantic associations.
The English Queen Elizabeth I and her suitor Robert
Dudley, Earl of Leicester, were both keen hunters and
had a silver plate with their coats of arms attached
to this medieval citole covered with hunting scenes.
This imagery seems harmless enough, especially in
the context of such an elegant and venerable stringed
instrument: a citole is an archaic form of guitar. Yet
the chase was also a symbol of power, as in Tudor
England it was restricted, on pain of death, to monarchs
and the aristocracy.

Falconry is an elite form of hunting that involves considerable training and skill. In this Chinese painting, the falconer and the peregrine gaze at each other as if their lives depended on it. Meanwhile a horse, with a tiger skin draped over its back, waits patiently for its owner, who holds a whip behind his back. Everything, including the blades of grass, is represented with great economy, a quality that was valued by collectors, whose seals appear plentifully on the surface of the painting.

Horse and Falconer
Formerly attributed to Chen
Juzhong (active 1201–1230)
1200–1300
China
Ink and colour on silk
H 24.8 cm, W 26.3 cm

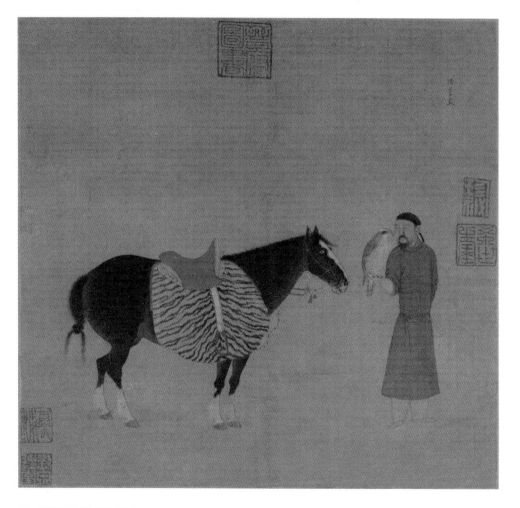

Falconry's aesthetic qualities lend it a romantic allure
in the Qajar tile from Iran, in which the falconer is
shown embracing a female musician. In contrast, the
Mughal Emperor Jahangir appears to turn his back
on his page, though the servant was in fact added
a decade later. Both figures, however, are united not
only by their shared activity but by the beauty of their
clothes, rendered in ink, watercolour and gold.

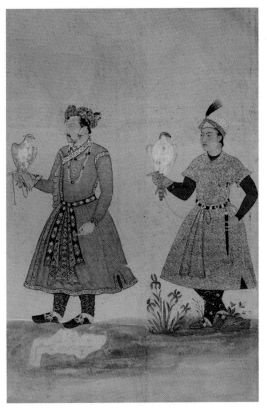

Hunting boar was an activity favoured by the elites in various societies, including late 18th-century India. The hunters were usually victorious, though there was just enough of a whiff of danger, as conveyed in this gouache painting, to give the activity a certain glamour.

In Greek mythology, the Calydonian Boar was a particularly fearsome beast, which the hero Meleager killed, sharing the spoils with the virgin huntress Atalanta, the first in the hunting party to pierce the Boar's hide. Meleager's gallant gesture has been represented on the back of a woman's mirror in luminous Limoges enamel. Unfortunately, in awarding the hide to a woman, Meleager gave offence to his uncles, eventually leading to multiple deaths, including his own.

ABOVE

A wild boar hunt
c. 1755
India
Gouache painting on paper
H 31.8 cm, W 53.6 cm

ABOVE

Painted Limoges enamel mirror
Attributed to Jean Guibert
c. 1600
Made in Limoges, France
Gold, enamel and copper
L 9.25 cm, W 7 cm (in frame)

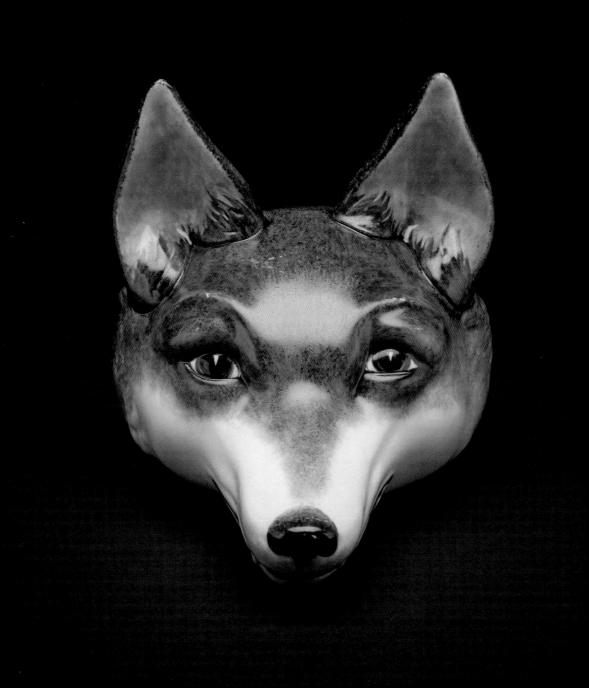

Stirrup cup in the form of a fox
mask inscribed 'Tally Ho'
c. 1810–20
Made by the Derby Porcelain
Factory Derby, England
Bone china
H 12.9 cm, W 11.8 cm

Red figure pottery rhyton
with a fox's head
Greek, 340–315 BC
Made in Apulia, Italy
Pottery
H 17.75 cm

This fox-shaped porcelain cup was handed to British hunters while they were in the saddle, that is to say with their feet in the stirrups, in order to fortify them before they rode off. As the cup did not have to stand on a table, its base was not flat but in the form of an animal's head, usually a dog or, as here, its quarry. Stirrup cups recall ancient Greek rhytons, which were also meant to be held and quaffed rather than placed on a table. This example also has a fox's head, though rhytons could take the form of various wild, fantastic or domesticated animals.

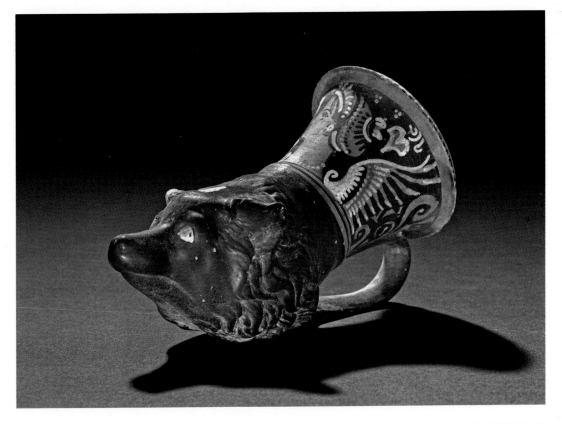

The Human Animal

According to a Japanese saying, monkeys are 'only three hairs from being humans', though they are also believed to serve as messengers of the gods. These monkeys, intently inspecting a blueberry, are dynamic and highly interactive. For once, the anthropomorphic element that is so common in animal art actually reflects reality.

In the mythology of the ancient Huaxtec people, who lived on the Gulf of Mexico, monkeys originated in a pre-human era of creation. Clearly this sculptor saw them as sharing many qualities with the people that came after them. They were particularly associated with sexual freedom, and their fecundity is probably the reason for the choice of a greenish material in this figure.

OPPOSITE

Vessel in the form of a crouching monkey
c. 900–1521
Mexico
Onyx, iron
H 23.5 cm

RIGHT

Monkey and young
Mori Sosen (1747–1821)
c. 1800
Osaka, Japan
Hanging scroll, ink and colours on silk
H 105.7 cm, W 38.5 cm

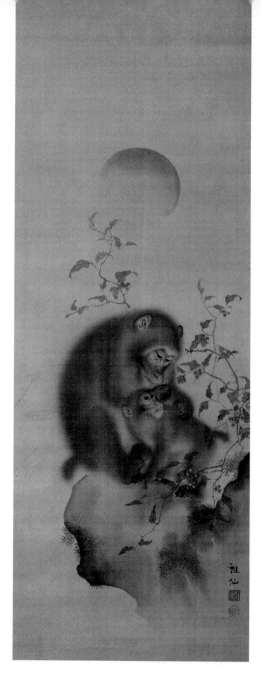

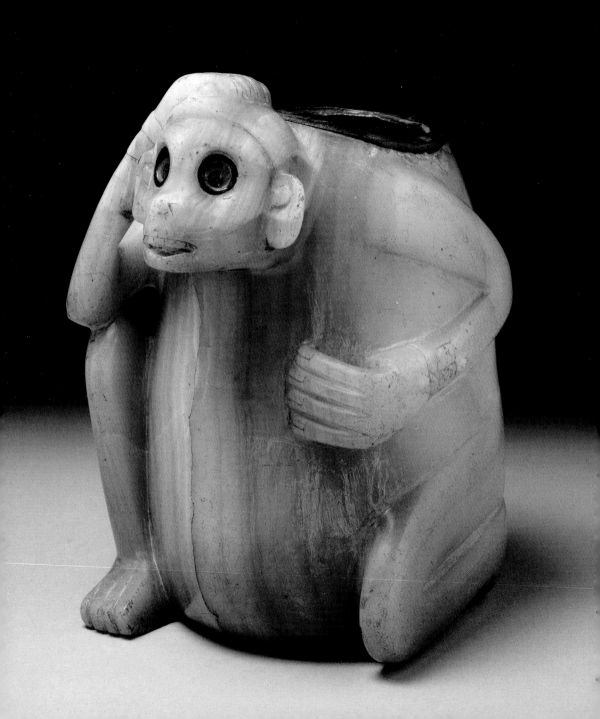

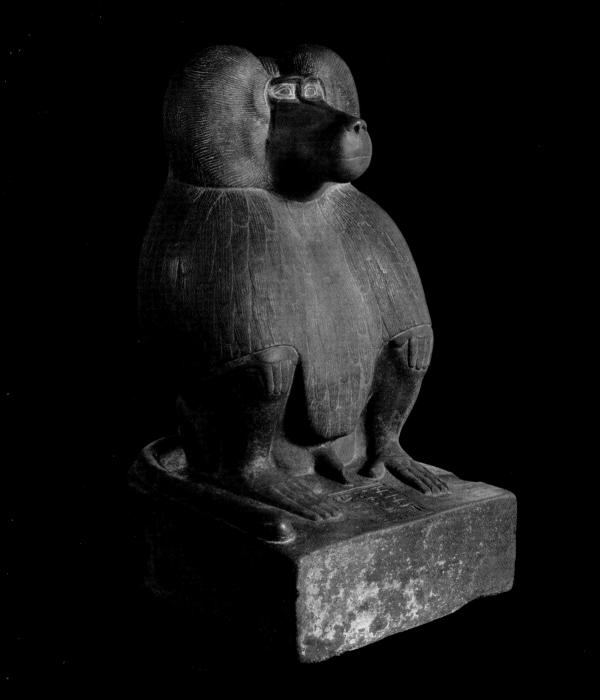

A divine baboon

18th Dynasty, reign of
Amenhotep III, c. 1370 BC

Egypt

Quartzite

H 68.5 cm, W 38.5 cm

Figurative gold-weight in the form
of a seated baboon or monkey
holding a fruit to its mouth

1700–2000

Akan People, Ghana

Brass

H 3.2 cm, W 1.5 cm

Baboons screech at sunrise. This is why in Egyptian mythology they were associated with the sun-god, although this statue has also been connected to Thoth and Hapy, respectively deities of wisdom and the life-giving Nile flood. Although linked to divinities, the figure undoubtedly has human qualities, above all its pensive expression. Its static, frontal pose, so typical of Egyptian sculpture, is combined with a minute attention to its features. The object has been carved from the warm quartzite stone favoured by the pharaoh Amenhotep III, whose name appears in the inscription on the base.

In contrast to the Egyptian sculpture, the Akan figure from Ghana is an animated baboon or other species of monkey holding some food, perhaps fruit, to its mouth. The accuracy of gold-weights was crucial to the Akan economy, yet this did not stop craftsmen from producing lively, distinctive objects. In this case, the subject is highly appropriate: one of the many proverbial statements with which monkeys were associated was 'If you fill up my cheeks [with food], then I shall reveal the truth...'

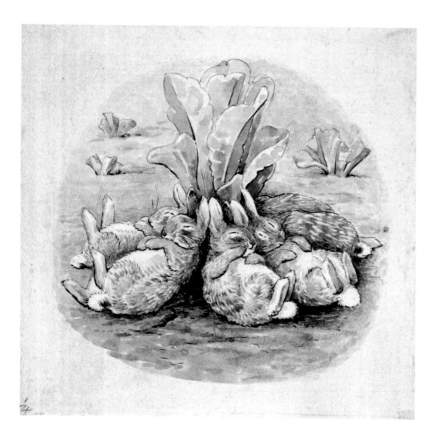

What better subject for a group of animals to discuss
than their ill treatment by humankind? This may be the
subject of the Mughal watercolour, which has been
linked to the 16th-century Ottoman poet Lâmiî Çelebi's
'Şerefü'l-Insan'. From the top of a mountain, the raven
addresses an assembly of animals that includes fish,
owls, cranes and ducks, as well as lions, tigers and a
smiling cheetah, and a variety of fantastic creatures.

The anthropomorphism of wild animals reached new
heights in the illustrated children's books of Beatrix
Potter. In 1909, she presented the 'Flopsy Bunnies' in the
eponymous story overcome by the 'soporific' effects of
eating lettuce. The well-loved rabbits were the children of
Benjamin Bunny, whom Potter named after one of her own
pets, blurring the division between domestic and wild.

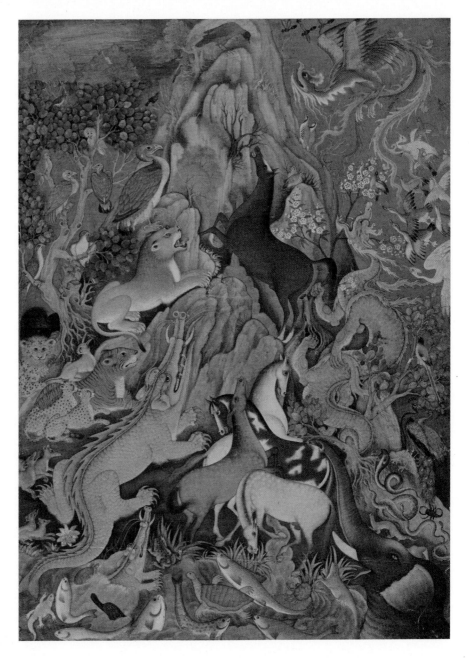

By substituting human heads for animal ones, the creator of this English print has turned the French politician Prince Jules de Polignac into a frog, a popular sobriquet for the French, while his political adversary the Duke of Wellington has been given the strength and fortitude of a bull.

The frog and the bull
John Doyle (1797–1868)
1829
British
Lithograph
H 29.2 cm, W 41.7 cm

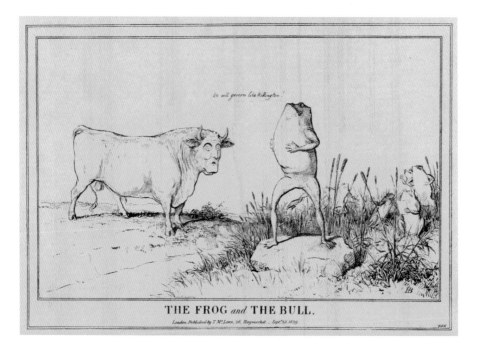

THE FROG *and* THE BULL.

London. Published by T. MᶜLean, 26, Haymarket. . Septʳ 23. 1829.

A similar effect was created in this cabinet of curiosities of the same period, a grotesque satirical image of contemporary French politicians. The men, each identified by mock Latin labels, may no longer be household names, but the moral and physical associations of the animals, including a snake, a seal and a bat, still resonate.

Cabinet d'histoire naturelle
from 'La Caricature'
Eugène Forest (1808–91)
and J.J. Grandville (1803–47)
1833
French
Hand-coloured lithograph
H 26.6 cm, W 45.7 cm

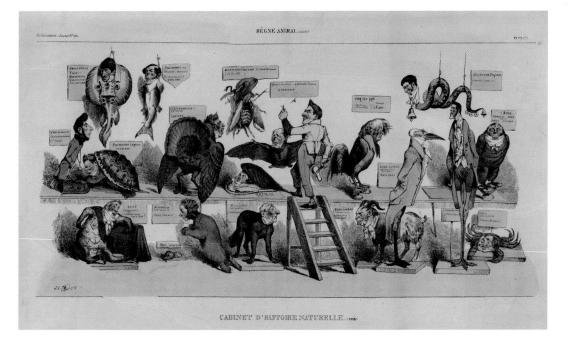

Observation of Nature

In his *Natural History*, Pliny the Elder described a Greek mosaic of drinking doves that was so realistic that other birds collided against it. Pliny's account was so compelling that in the 18th century, Giacomo Raffaelli, working in the delicate technique of micro-mosaic, created an illusionistic image based on a Roman version from Hadrian's Villa of the lost Greek prototype.

The degree of naturalism actually achieved in classical mosaics is exemplified by an elegant Roman composition depicting a plethora of marine specimens. The fish and other creatures depicted here were edible, and probably adorned a dining room.

LEFT
Doves of Pliny micromosaic
1779
Made by the workshop
of Giacomo Raffaelli
Rome, Italy
Glass and copper
Diam 5.6 cm

OPPOSITE
Panel from a mosaic floor
depicting edible fish
Roman, c. AD 100
Said to be from Populonia, Italy
Stone
H 88.9 cm, W 104.1 cm

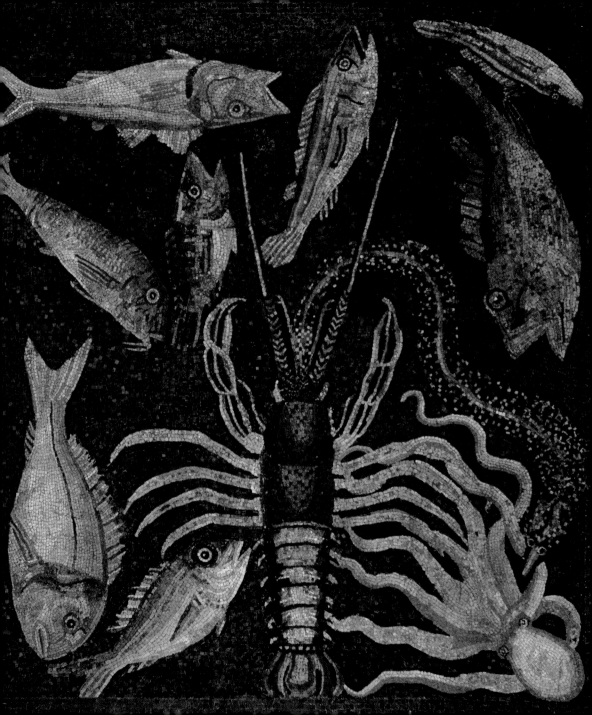

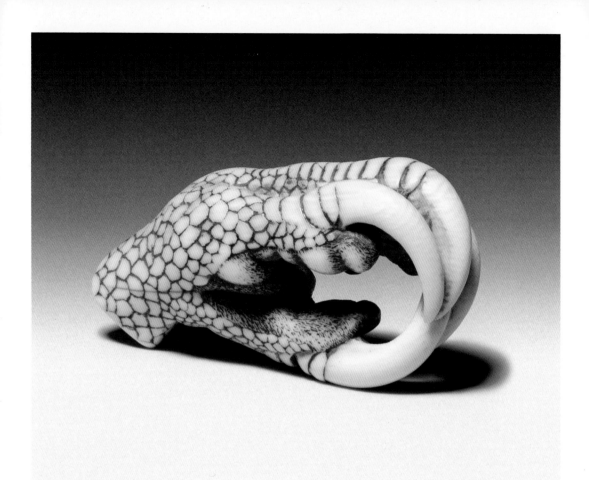

The Japanese netsuke, a toggle for a kimono sash, is carved from ivory to represent a bird's claw. The accurate depiction, including the scales at the base of the claw, is reminiscent of illustrated books of this period. Its naturalism contrasts with the luxurious document box decorated with interlocked crows and egrets. The pattern is so abstract that the eye takes some time to distinguish the individual birds. The sense of richness is enhanced by the materials, which include lacquer and mother-of-pearl.

Hawk's claw netsuke
By Masanao of Kyoto
Late 1700s
Kyoto, Japan
Ivory
W 5.9 cm

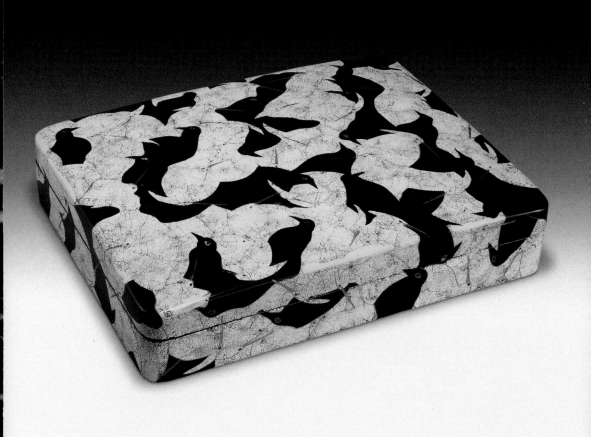

Lidded document box decorated
with interlocking crows and egrets
19th century
Japan
Wood, mother-of-pearl and
lacquer
H 6.2 cm, W 30.5 cm, L 24.3 cm

Naturalism and artifice are brilliantly combined in these paintings, which decorated the sliding doors of the Tanzan shrine near Nara in Japan. On the left, three geese, with credible poses, are set in an idealized, glittering landscape, which sets the tone for the whole ensemble. For all its poetic, almost elegiac quality, the composition is filled with precise observations of nature. Subtle changes of environment express the passing of the seasons, while different species of birds – plovers, ducks and geese – stand, swim or fly with striking realism.

Birds and flowers of autumn
and winter
Early 17th century
Japan
Four sliding door panels, ink,
colours, gold and silver on paper
H 173.5 cm, W 141 cm (each)

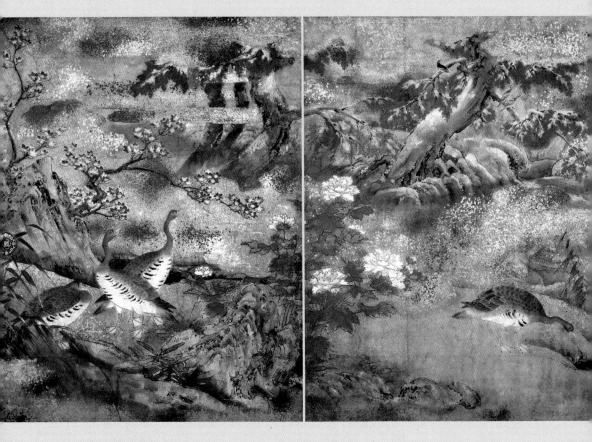

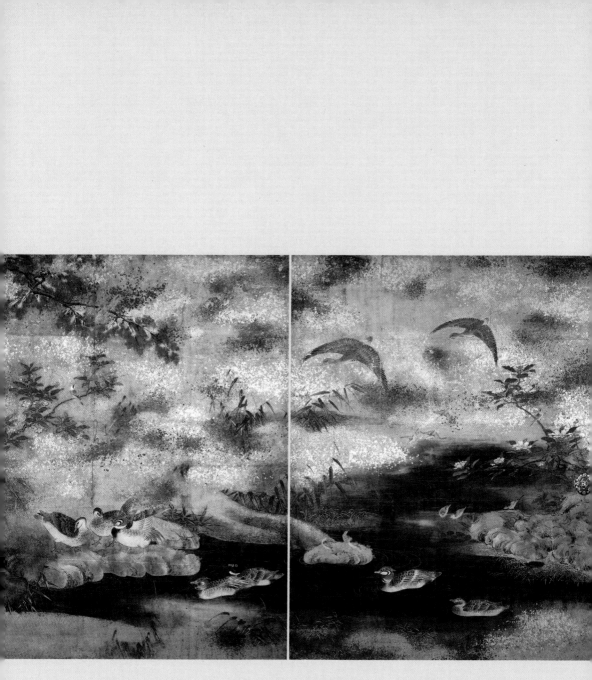

In East Asia, deer are often regarded as sacred and roam in the parks around Buddhist shrines. The objects here reflect this veneration but, as they were made for the export market, were intended above all to display the artistic skill for which Asian lacquer-workers were renowned. Both artefacts represent the animals and their setting in some detail, with the Japanese example showing the creatures in particularly naturalistic and expressive poses.

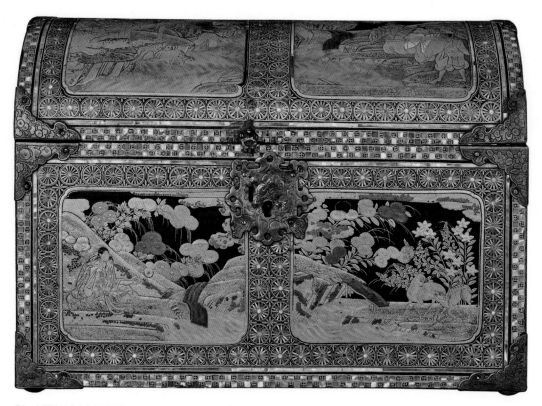

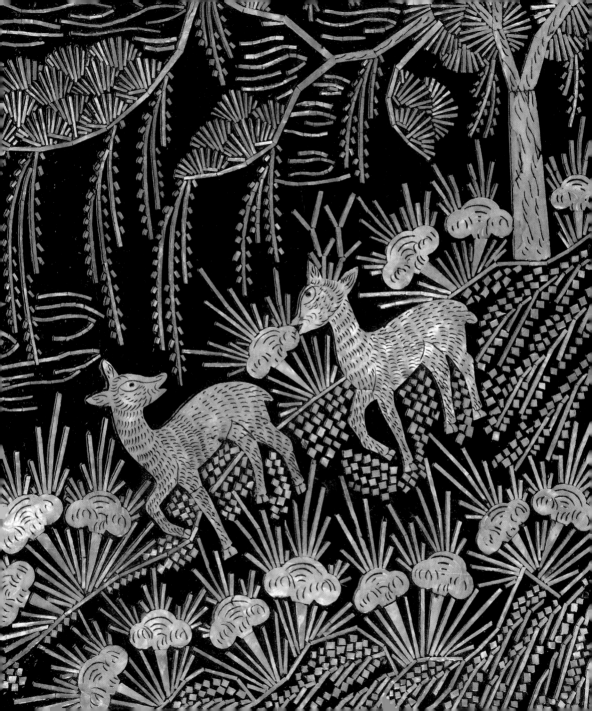

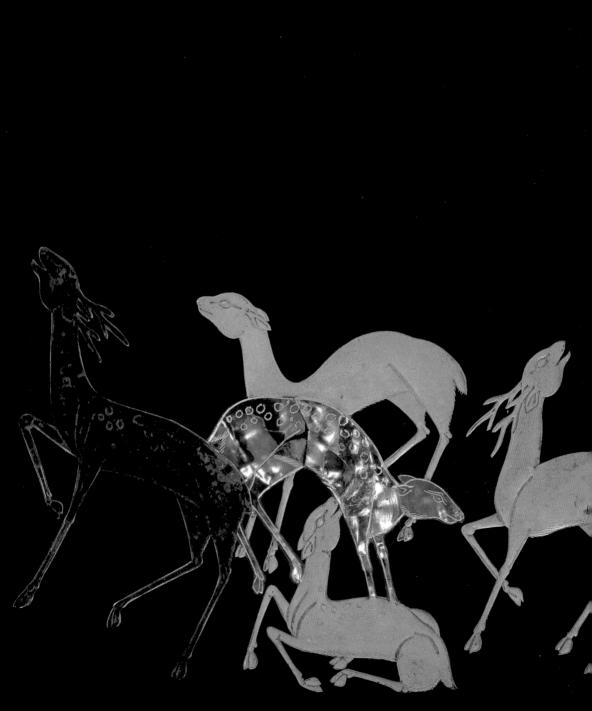

Deer crying in autumn is the theme of the image in black lacquer, the inside lid of a writing-box. This private, luxury object uses mother-of-pearl, which, silhouetted against the background, creates a dynamic, flickering effect. The drawing by Sir Edwin Landseer is far more static, emphasizing the stag's noble pose and expression, features that the artist famously represented in his monumental oil paintings.

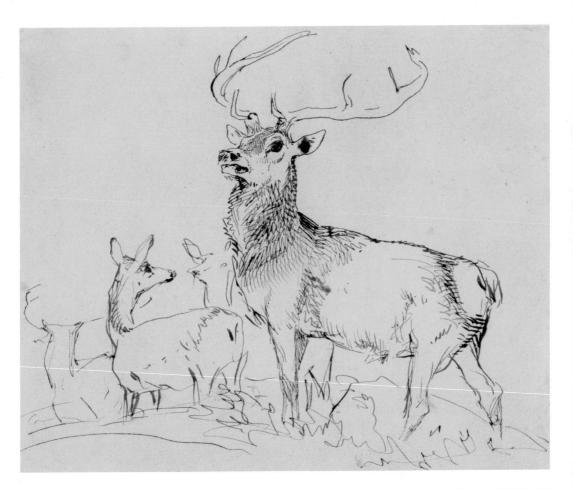

This silver coin, a stater from the Greek island of
Aegina, depicts a common species of tortoise,
represented in high relief with a great degree of
delicacy and detail. Even more remarkable is the
terrapin from India, which is made of jade, a hard and
demanding material, and yet is so accurate that it can
be easily identified as the female of a local species.
It was perhaps made for the Emperor Jahangir, an
amateur naturalist, to adorn his palace in the castle
at Allahabad.

Carving of a terrapin
Early 17th century
Found at Allahabad, India
Jade (nephrite)
H 20 cm, W 32 cm, L 48.5 cm

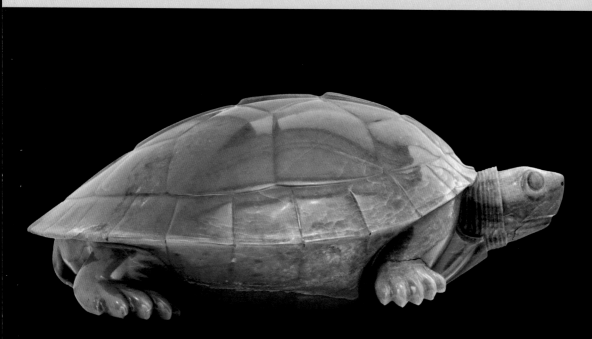

Silver stater with a tortoise
(reverse)
480–431 BC
Minted in Aegina, Greece
Diam 2.2 cm

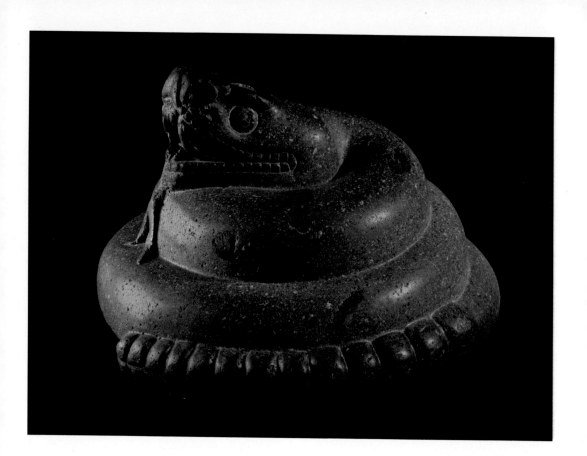

This full-length rattlesnake, made by an Aztec
sculptor, has many features that are based on precise
observation. As well as the fangs and forked tongue,
the creature has heat sensors and a movable trachea,
and traces of pigment show that it was painted a
reddish hue. By contrast, the head from Nigeria is
identifiable as a python in spite of the stylization,
even simplification, of the animal's features.

In the Aztec sculpture, naturalism is combined with a
symbolic quality. The rattle, for example, is divided into
thirteen segments, a number with ritual significance.
The image would undoubtedly have been regarded as
representing the Aztec sense of a divine order, which
embraced both the cosmos and the earth.

Coiled rattlesnake figure
Aztec, c. 1325–1521
Mexico
Granite
H 36 cm, Diam 53 cm

Cast brass head of snake
c. 1700–1800
Benin City, Nigeria
Brass
H 15 cm, W 29.5 cm

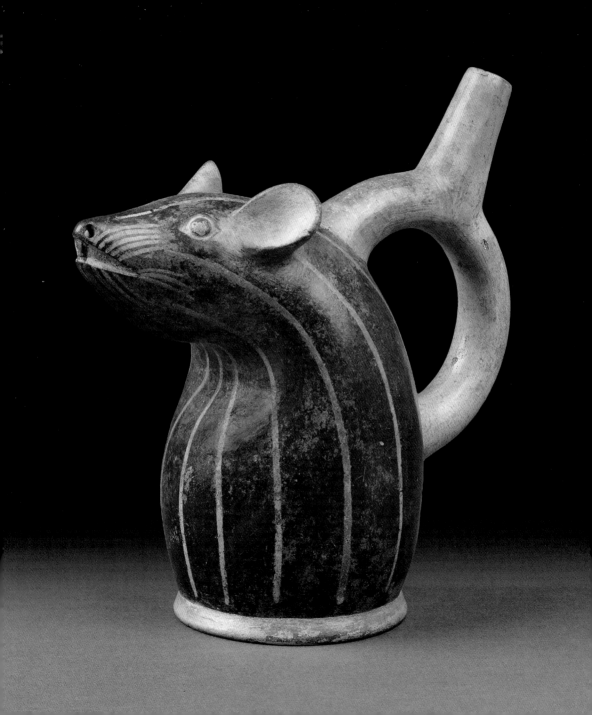

Rodents are not the most alluring of animals. However, these examples, from Japan, Egypt and the Moche culture of pre-Columbian Peru, display fine observation and craftsmanship. The reasons for choosing these species in these contexts remain unclear, although the Egyptian jerboa may be a kind of scenic accessory, intended to evoke the desert environment of the more significant funerary images with which it was found.

OPPOSITE

Stirrup spout vase in the form
of a rodent
Moche, 100 BC–AD 700
Trujillo, Peru
Pottery
H 22 cm, W 10 cm

RIGHT, TOP

Sleeping rat netsuke
By Masanao of Kyoto
Late 1700s
Kyoto, Japan
Ivory
W 5.7 cm

RIGHT, BOTTOM

Model of a jerboa
13th Dynasty, c. 1850–1650 BC
Matariya, Egypt
Glazed composition
H 4.4 cm, W 2.8 cm

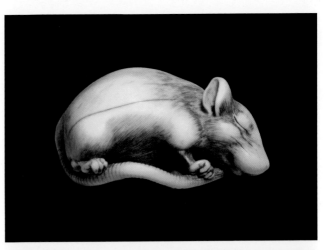

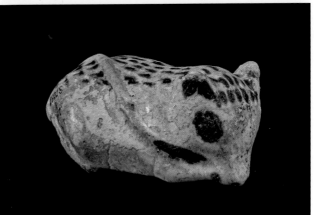

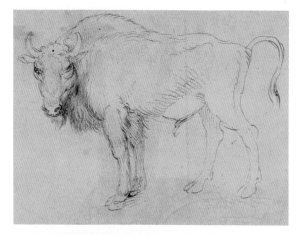

LEFT AND BELOW

**Drawing of an elk (recto, below)
and a European bison (verso, left)**
Albrecht Dürer (1471–1528)
c. 1501–4
German
Pen and black ink with
watercolour (recto);
Pen and black ink (verso)
H 21.3 cm, W 26 cm

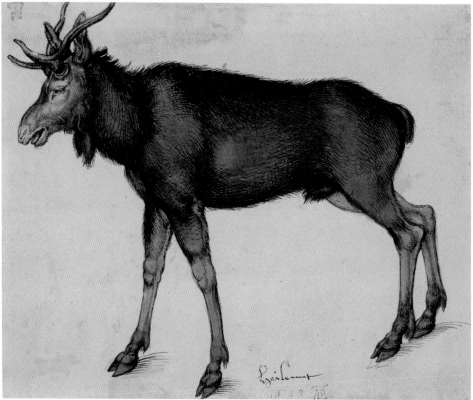

For all his brilliance with fur and other textures, Dürer did not give his watercolour of an elk the vigour of the bison on the reverse side. The elk may indeed have been based on a preserved specimen, while the bison was perhaps one of five given to the King, later Holy Roman Emperor, Maximilian on his visit to Nuremberg in 1501.

Thomas Bewick famously depicted the herd of cattle that still roams the Chillingham estate in Northumberland. Although they live as wild animals, they are probably the descendants of an ancient domesticated breed rather than a species of primeval cattle. Whatever its origin, in Bewick's hands the animal has an archetypal nobility.

The Wild Bull
Thomas Bewick (1753–1828)
c. 1789–1816
British
Wood engraving with letterpress
H 13.9 cm, W 19.4 cm

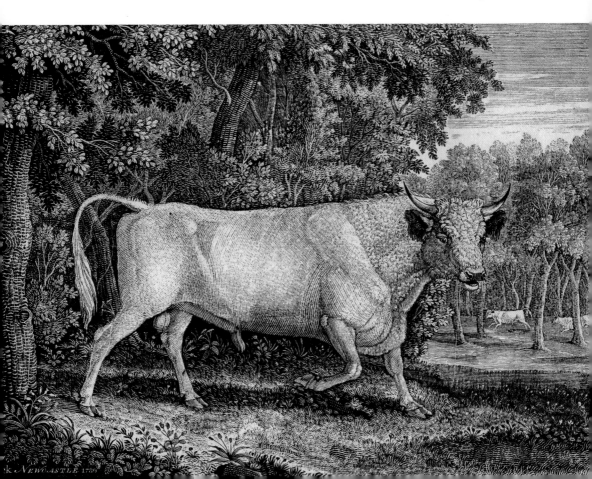

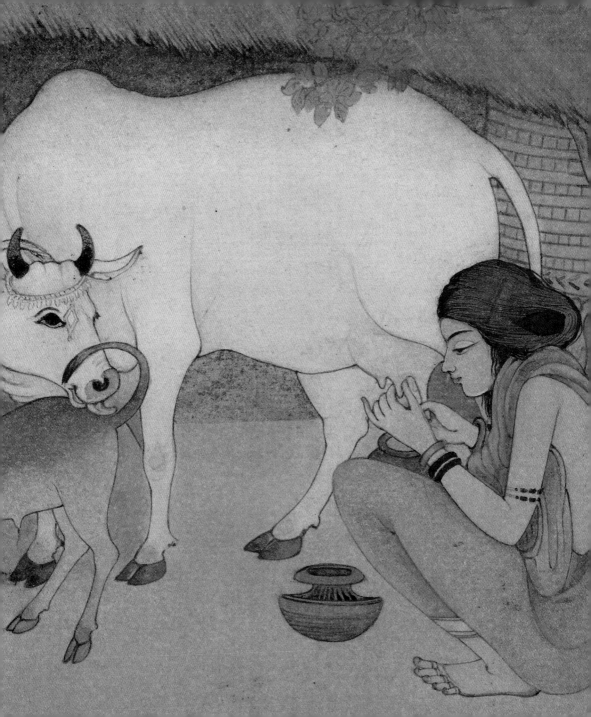

— 2 —
DOMESTIC

HUMANITY'S ASSOCIATION WITH THE natural world is primarily about exploitation. Animals have been used in warfare, as beasts of burden and as sources of clothing, milk and, above all, meat. Given the economic importance of these roles, it is unsurprising that domestic creatures are represented in so many contexts, and sometimes in the most luxurious of settings and materials.

The Standard of Ur (detail)
See page 80

The brutality of our treatment of animals is not always honestly depicted, but in Rembrandt's etching there is no doubt about the fate of the pig, which lies with its trotters trussed, awaiting the axe (page 70). Other images represent the kinder aspects of the relationship. Canine domestication goes back to prehistoric campfires, but by the time that a Roman sculptor carved the Townley Greyhounds, hunting was an elite activity, pursued with the help of recognizable breeds (pages 90–91). The hounds are shown tending each other with a delicacy that reveals as much about the human sympathy for dogs as it does about their own affections.

This intimacy between humans and domestic animals appears continually in art, and not just in images of 'man's best friend'. Samuel Howitt expresses our tenderness for cats, although their harder, more aggressive side has attracted the attention of artists from Sir John Tenniel to Cornelis Visscher. Ancient Egyptians placed a particular importance on this species, creating feline artefacts that express the distinctiveness of their culture (page 98). Perhaps only a civilization that broke the necks of mummified cats could produce such hieratic images.

Animals have, of course, been sacrificed by many societies, as the Parthenon sculpture of a heifer demonstrates (page 102). One of the most persistent sacrificial themes is the ritual struggle between man and the bull, a beast that seems worldwide to symbolize a form of archetypal darkness. Bulls are stabbed and slayed, and even leaped over. Although they were first domesticated from wild aurochs around 10,000 years ago, bulls demonstrate, in art and in wider culture, the narrow divide between domesticity and the wilderness from which we ourselves sprung.

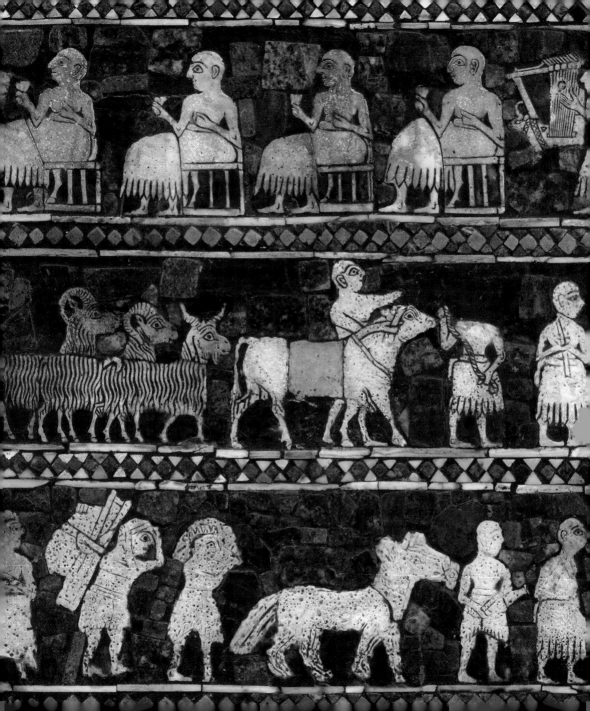

Livestock and Beasts of Burden

The domestication of animals serves a number of
purposes, but slaughtering and eating them is high
on the list. In Rembrandt's print, a butcher with an
axe can be seen in the background while one of the
watching children holds a pig's bladder. The hog,
bound by its trotters, awaits its fate.

The hog
Rembrandt (1606–69)
1643
Dutch
Etching and drypoint
H 14.5 cm, W 18.5 cm

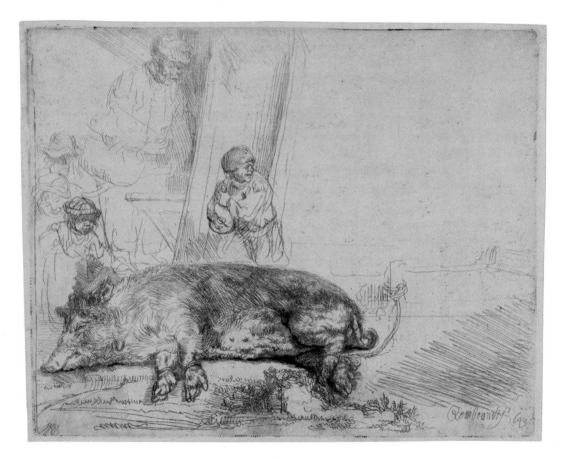

A pig organ
Anonymous
c. 1800–10
British
Etching
H 20. 2 cm, W 26 cm

Rembrandt's naturalistic image contrasts with this etching of a pig organ, which is so grotesque that it looks like a satire of the human condition rather than a document of the treatment of animals. Yet, amazingly, 19th-century, and earlier, entertainers did construct 'organs' made up of animals of different sizes goaded into squealing in a range of pitches. The means of stimulation can be seen at the back of the instrument: the pigs are having their tails pulled. Judging by their expressions, this is quite painful.

Double-humped Bactrian camels were the indigenous means of conveyance in large areas of Asia. Their importance in the ancient world can be seen in the Assyrian obelisk of Shalmaneser III, in which they are part of the tribute brought from different lands to the king. The much later Tang Dynasty figure from the tomb of the commander Liu Tingxun is one of a whole travelling company that offers a vivid image of life on the Silk Road. Its real-life inspiration would have carried numerous luxuries, such as spices and of course silk, along the route. A 'monster mask' on its saddle wards off danger, as does as an accompanying fantastic guardian figure (page 204).

Tall, elegant horses were part of the valuable trade that passed along the route from the west, though they were also used as beasts of burden. Their long-standing status as an elite form of transport in Asia is neatly represented by the warrant that a government messenger needed in order to ride on horses in 17th-century Korea.

BELOW
Official horse warrant
1624
Korea
Bronze
Diam 10.3 cm

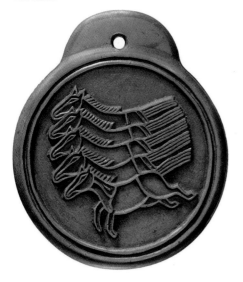

BELOW
The Black Obelisk
of Shalmaneser III
825 BC
Found in Nimrud, Iraq
Black limestone
H 197.48 cm

OPPOSITE
Sancai tomb figure of a camel
Tang dynasty, c. AD 728
Luoyang, China
Earthenware
H 83.8 cm

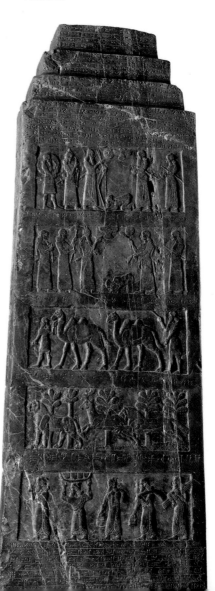

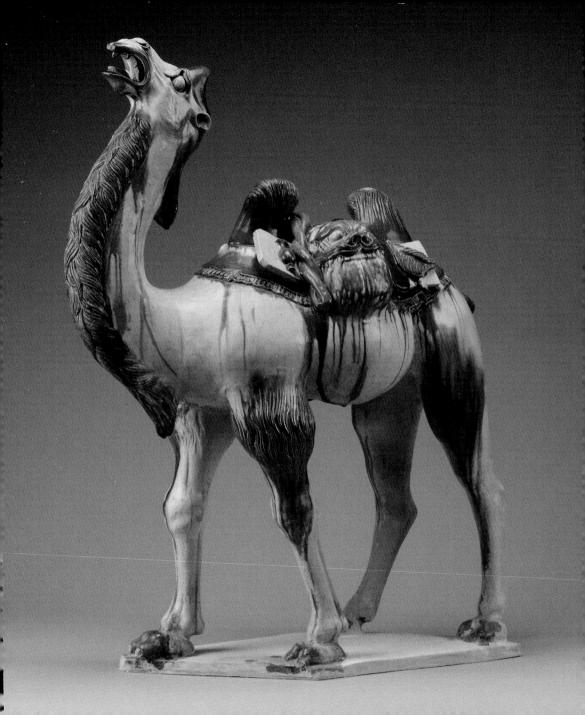

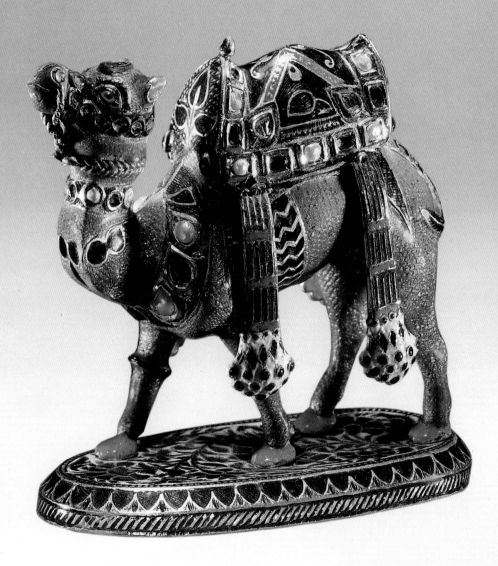

OPPOSITE

Camel figurine

c. 1850–60

Jaipur, India

Enamels on gold, inset with

diamonds, rubies, emeralds,

pearls and baroque pearls

H 5.6 cm

BELOW

Llama figurine

Inca, *c.* 1500

Peru

Gold

H 6.3 cm

This lavishly caparisoned Bactrian camel would have belonged to someone of very high status. It perhaps tells us more about the artist and his patron than about actual camels and their owners. The figurine is made, in the Mughal tradition, from polychrome enamels on gold, inset with diamonds, rubies, emeralds and pearls. It is a truly extraordinary image of a very ordinary species.

In Inca Peru, llamas functioned as military pack animals, agents of imperial domination in their empire. Despite their ubiquity, llamas were obviously regarded as important enough to be represented in gold, the material associated with the sun-god. Indeed this cheerful-looking animal may have been intended as an offering, a surrogate for the real llamas that were killed in religious sacrifices.

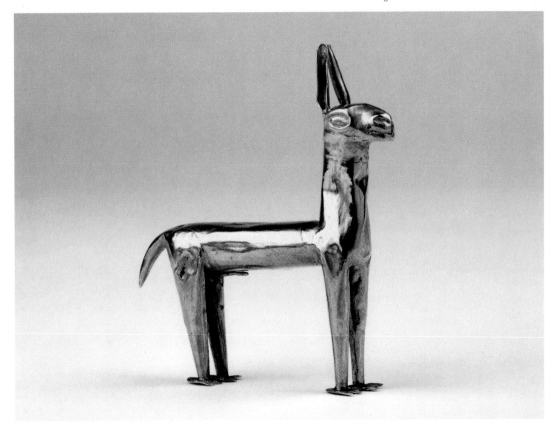

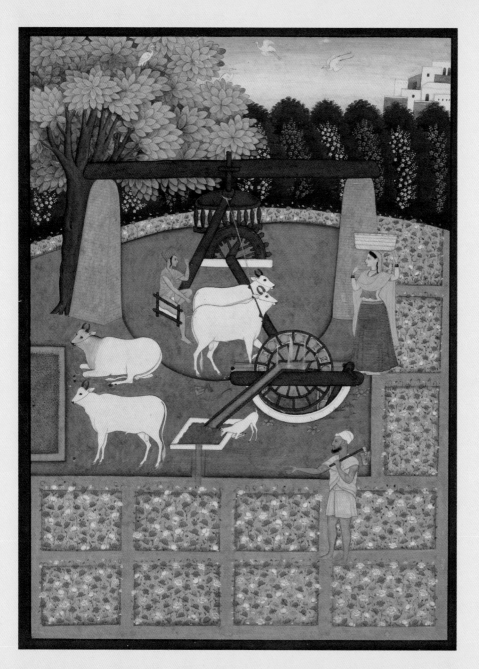

OPPOSITE

Lovers meeting in a garden
beside a water wheel with oxen
c. 1760
Panjab Hills, India
Painted on paper
H 27 cm, W 20.5 cm

BELOW

Model group of a farmer and
two oxen
c. 1985–1795 BC
Egypt
Wood
H 20.3 cm, L 43.2 cm

OVERLEAF, LEFT

A woman milking a cow while
a boy holds the calf
By Surendra Nath Kar
Early 20th century
India
Painted on paper
H 18.5 cm, W 19.5 cm

OVERLEAF, RIGHT

Scene from the Gazi Scroll
c. 1800
Bengal, perhaps the Murshidabad
district, India
Painted on paper
L 13 m (scroll)

The owner of the Egyptian tomb in which this
charming model was found would never lack grain in
the afterlife. A pair of speckled oxen, led by a kilted
peasant ankle-deep in soil, draws a wooden plough.
Such agricultural scenes were accompanied by
images of food in Egyptian funerary art.

Another role of oxen in a pre-mechanical society is
depicted in the North Indian painting as they turn a
water-wheel in a garden. Animals and people alike
congregate around the source of water.

Cattle are of course particularly important as sources
of milk. Surendra Nath Kar's painting of a woman
milking a cow, while a boy holds the calf, is both
tender and naturalistic in comparison with the 'Gazi
scroll'. This famous series of folk paintings, presenting
scenes from the lives of Muslim saints, includes an
image of a cow miraculously lactating when the holy
man touches its nostrils.

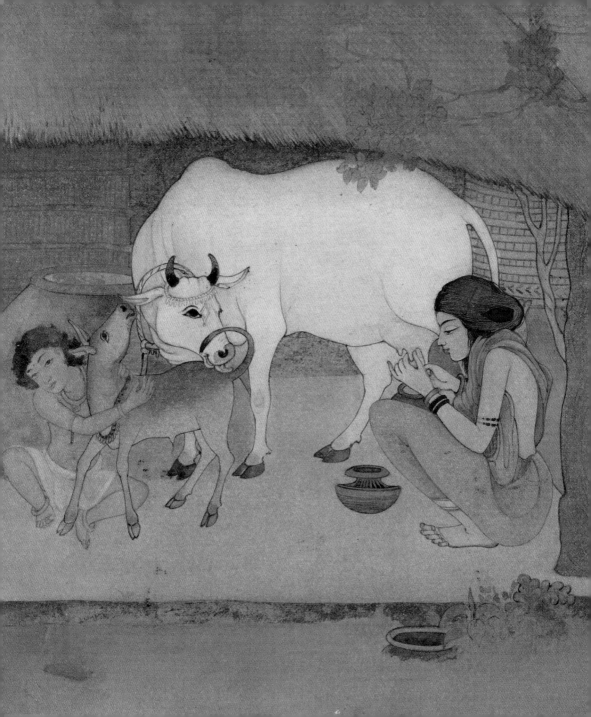

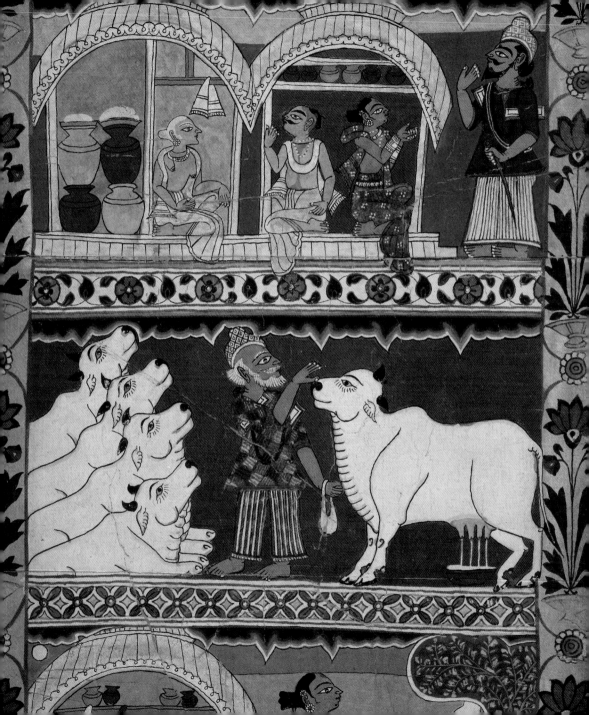

Court and Battle

Wagons or horse-drawn chariots were used in warfare in early civilizations in the Middle East and eastern Mediterranean. Although its function is enigmatic, the 'Standard of Ur' clearly represents a Sumerian military campaign. On the side illustrated here, the army is shown with its wheeled wagons and infantry charging the enemy. In the top register, prisoners are brought before a ruler, depicted on a larger scale than the people around him, who has his own chariot waiting behind him.

Chariots frequently appear in Mycenaen kraters, pottery vessels for mixing wine, which seem to have been made primarily for export. As well as their military functions, the vehicles often had sporting or ceremonial roles, especially in later classical cultures. The celebrated mausoleum from the 4th century BC at Halicarnassus, in modern Turkey, included a colossal example drawn by the magnificent horse illustrated here.

The Standard of Ur. Mosaic of shell, red limestone and lapis lazuli depicting scenes of war and a royal banquet c. 2500 BC
From the Royal Cemetery at Ur, Iraq
H 21.7 cm, W 11.6 cm, L 50.4 cm

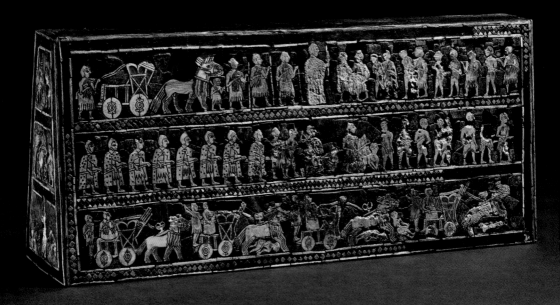

Mycenaean pottery amphoroid
krater
Greek, c. 1375–1300 BC
Made in Greece,
Found in Episkopi-Bamboula,
Cyprus
Pottery
H 42 cm

Colossal horse from the
Mausoleum at Halicarnassus
Attributed to Pytheos
Greek, c. 350 BC
Excavated in Bodrum, Turkey
Marble
H 2.33 m

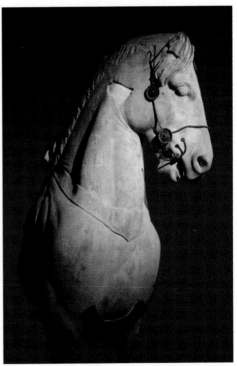

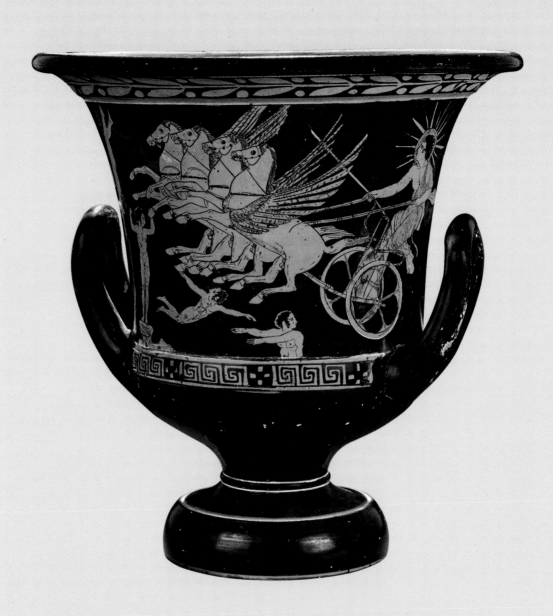

The Greek god Helios, in his chariot, pulls the sun in its journey across the sky on the side of this krater, used for mixing wine and water. He is crowned with rays, just as Selene, the moon-goddess, has a crescent on her head in the gemstone opposite. In an act of genius, the sculptor of the Parthenon pediment shows Selene's horse at dawn, as his nocturnal journey bearing the moon draws to its close. As he sinks below the horizon, the horse's bulging eyes and flared nostrils brilliantly express his exhaustion.

OPPOSITE

Red-figured calyx-krater
depicting the sun and the stars
Greek, c. 430 BC
Made in Attica,
Found in Puglia, Italy
Pottery
H 33 cm

RIGHT, TOP

Head of the horse of Selene
Attributed to Pheidias
Greek, c. 438–432 BC
From the east pediment of the
Parthenon, Athens, Greece
Marble
L 83.3 cm

RIGHT, BOTTOM

Gem engraved with Selene
Roman, 1st–3rd century AD
Sard
L 1.3 cm, W 0.9 cm

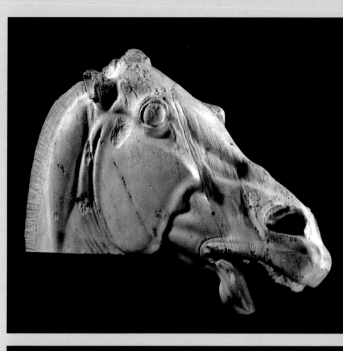

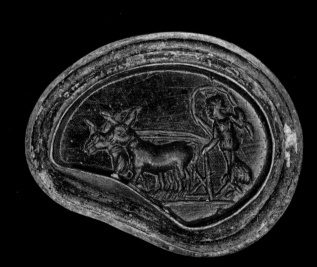

An equestrian setting certainly gives a sense of social status, and has done so for millennia. The brass sculpture from Niger was made relatively recently, in the 1960s or 1970s, for sale rather than as a commission. It is, however, a vivid portrayal of a dignitary on horseback, given distinction by his staff and robes as well as by the trappings of the horse.

In contrast to the Niger artist, the Roman sculptor of a Julio-Claudian prince has carved his figures from marble. He has shown his technical skill by using this brittle material to create a complex composition, with the horse's front hoof raised in a characteristic classical pose.

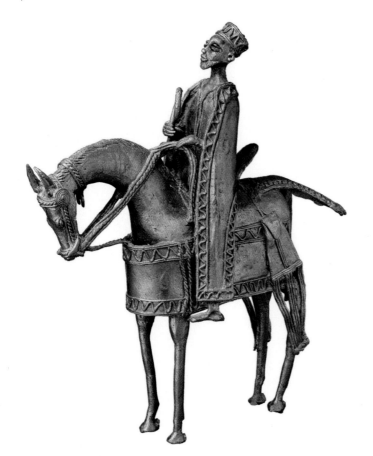

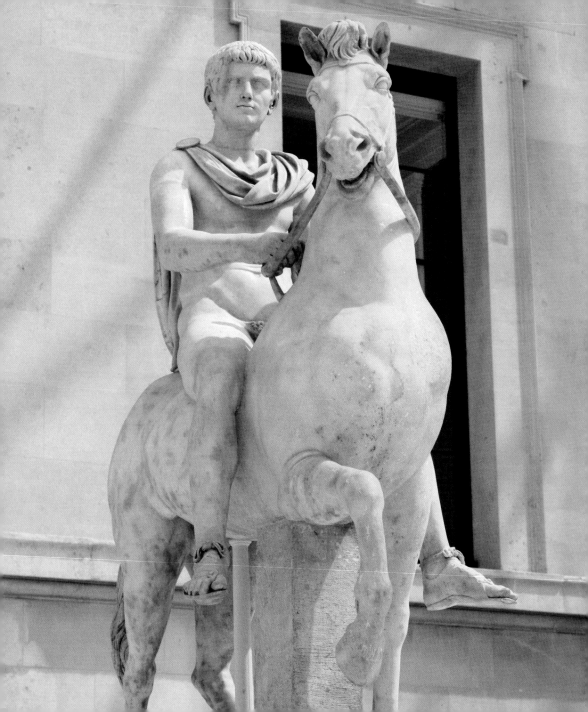

These images evoke the excitement of fighting on horseback. King Richard the Lionheart and Salah-al-Din meet in combat in a tile from Chertsey Abbey, even though they never actually encountered each other in the course of the Crusades. Equally dynamic is the seal of Robert Fitzwalter, one of King John's leading opponents, who charges on horseback with his sword raised and a dragon beneath his feet.

More fancifully, the craftsmen who made the cinerary urn from Campania in southern Italy in the early 5th century BC accompanied a pair of lovers with figures of Amazons mounted on elegant horses. These female warriors are shown in the act of firing their arrows, some of them twisting to shoot backwards.

OPPOSITE
Bronze *lebes* (bowl for mixing wine and water) used as a cinerary urn
Greek, *c.* 500 BC
Made in Campania
Found in Capua, Italy
H 67.3 cm

RIGHT
Seal-matrix of Robert Fitzwalter
c. 1213–19
From England
Silver
Diam 7.4 cm

BELOW
Tile showing Richard and Salah-al-Din
c. 1250–60
From Chertsey, England
Earthenware
L 17.1 cm, W 10.4 cm

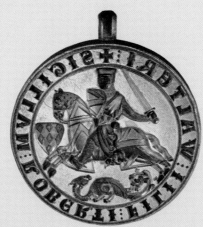

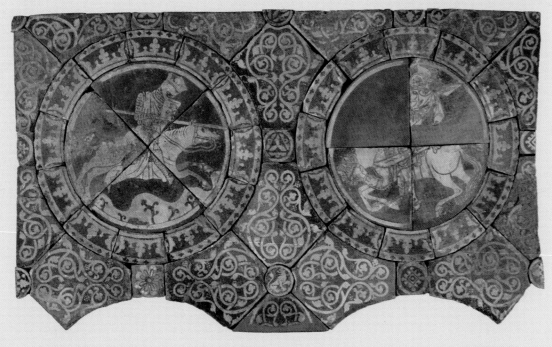

Exquisite as they are, these images of knights on horseback are relatively discreet. The 12th-century chessmen are compact, clearly defined figures, carved from walrus ivory in Trondheim, Norway, but found on the Isle of Lewis in 1831. The English medieval ewer was made out of a copper alloy for washing hands before a meal. It is a fascinating, and highly decorative, image of a late 13th-century knight, minus a few details such as his lance and his horse's tail. Despite the small scale of these objects, their associations with leisure and hygiene are in themselves indications of the owners' status, as is their artistic quality.

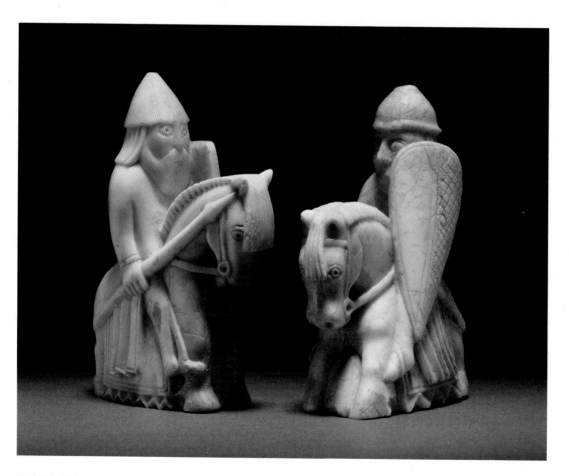

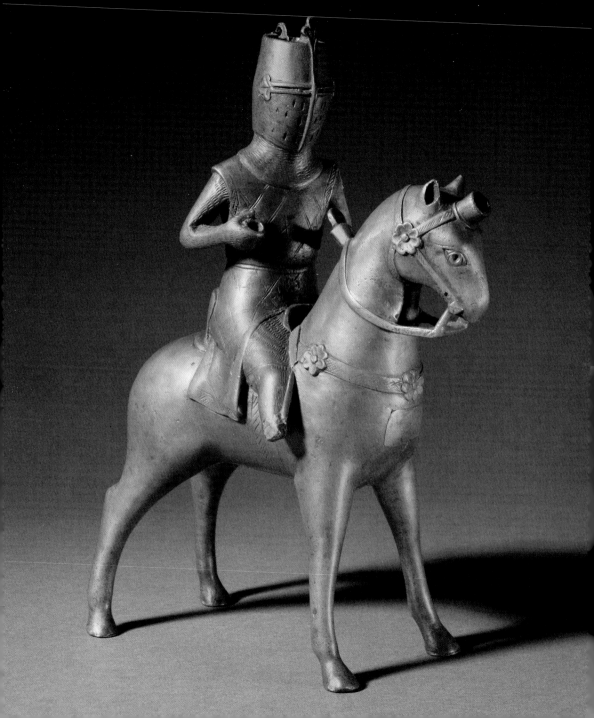

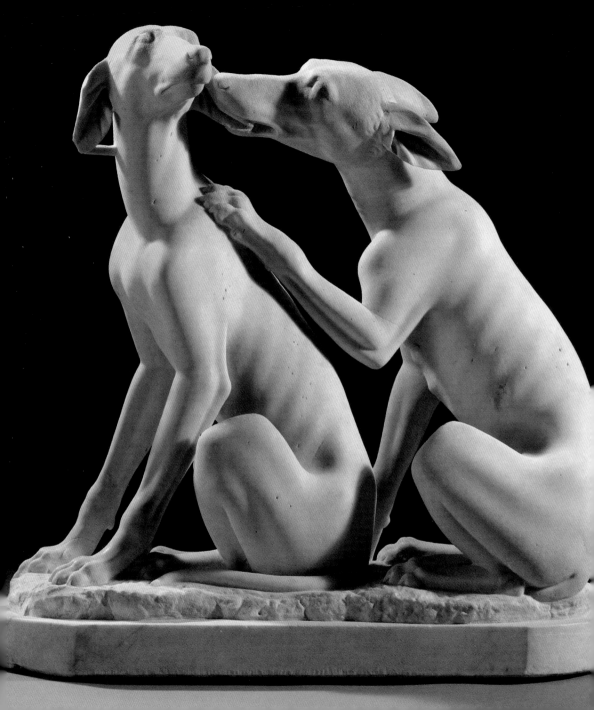

Companions

As hunting developed into an exhilarating pastime, dogs were bred to become sporting companions. The variety of breeds is illustrated by these ancient Roman sculptures. A ferocious Molossian hound, suited for either guard duty or hunting boar, rises up and turns his head, which has a cutting around the neck for a bronze collar.

This figure contrasts with a pair of lean, athletic greyhounds, ideal for running after smaller prey. Here the hounds are shown at leisure, with the female delicately caressing her mate. The dogs' mutual attention demonstrates the qualities that make them lovable pets as well as valuable hunting partners. These detailed Roman sculptures of dogs leave their enthusiasm for 'man's best friend' beyond doubt.

OPPOSITE
The Townley Greyhounds
Roman, 1st–2nd century AD
Found near Civita Lavinia
(modern Lanucio), Lazio, Italy
Marble
H 59.7 cm

RIGHT
The Jennings Dog.
Statue of a seated Molossian
hound
Roman, 2nd century AD
Marble
H 105 cm

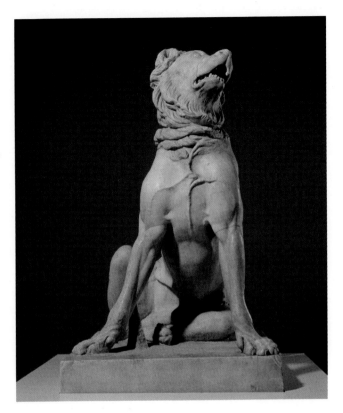

In contrast to the crispness of marble, silverpoint is an ideal medium for suggesting the softness of an animal's fur. In the hands of Albrecht Dürer, the precise drawing also gives a strong sensation of the sinews and bones of this creature, which the artist encountered on his visit to the Netherlands in 1520–21.

Drawing of a dog resting
Albrecht Dürer (1471–1528)
c. 1520–21
German
Silverpoint and charcoal
H 12.8 cm, W 18 cm

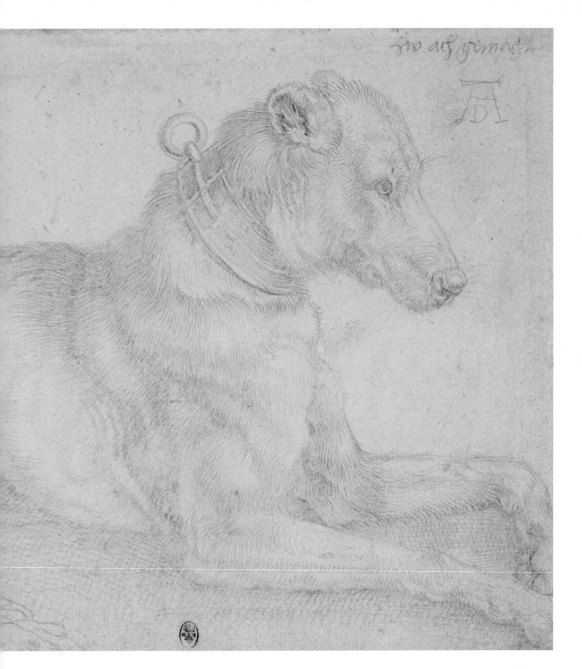

The celebrated porcelain factory at Meissen was adept at producing canine pets, complete with collars, scratching themselves and otherwise looking charming and vivacious. However, in the case of the model pugs there was also a more serious purpose. Renowned for their loyalty, this breed became the symbol of the Order of the Pug, a secret society established after Pope Clement XII prohibited membership of the Freemasons in 1738. These pugs may have been commissioned by members of the Order as table ornaments.

Pair of models of pugs
scratching themselves
1745–50
Made by the Meissen Porcelain
Factory, Germany
Hard-paste porcelain
H 5.6 cm (left) and 5.7 cm (right)

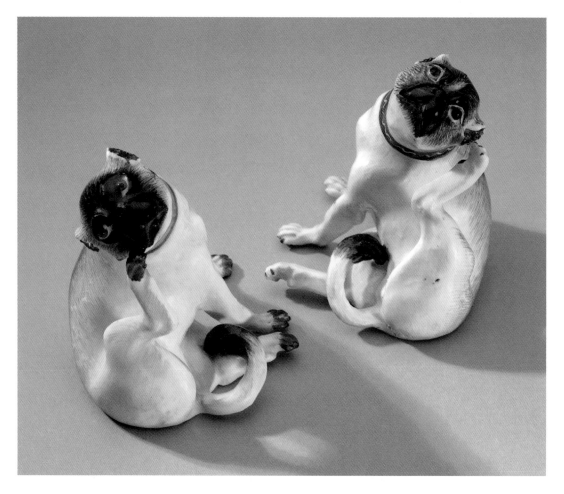

Model of a herding dog
1745–50
Made by the Meissen Porcelain
Factory, Germany
Hard-paste porcelain
H 12.2 cm

Wild, snarling dogs are fitting companions for Bhairava, a fierce manifestation of the Hindu god Shiva. Bhairava appears naked, like the ascetics who take him as their model, accompanied by carrion-eating dogs. In this painting, he carries a skull-cup to collect alms. Despite this morbid tone, the deity has a paradoxical identity. His ability to unite opposites is expressed by the granite figure's smiling expression as well as by the flowering landscape in the painting.

BELOW

Shiva as Bhairava with two dogs
c. 1820
Panjab Hills, India
Painted on paper
H 25.8 cm, W 34.9 cm

OPPOSITE

Figure of Shiva as Bhairava
c. 1000–1100
India
Granite
H 115.8 cm, W 48 cm

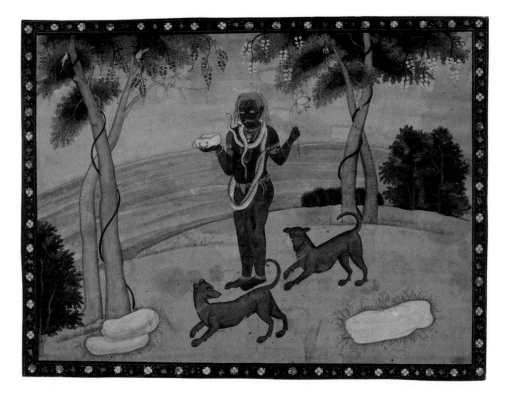

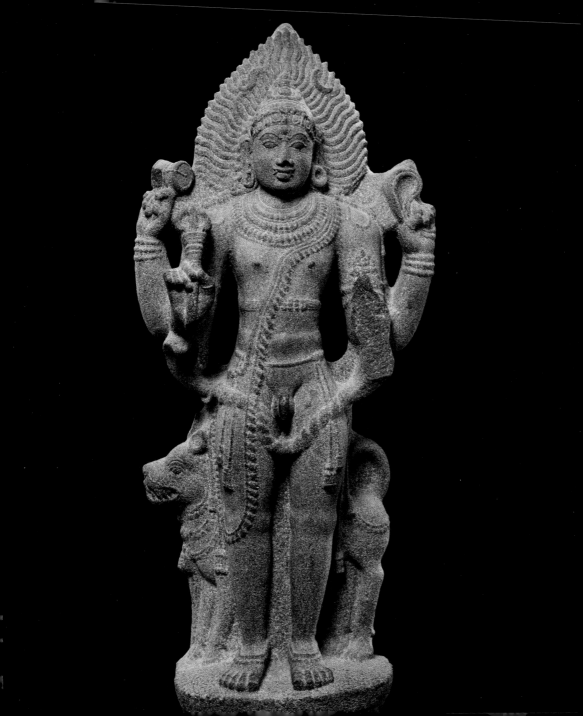

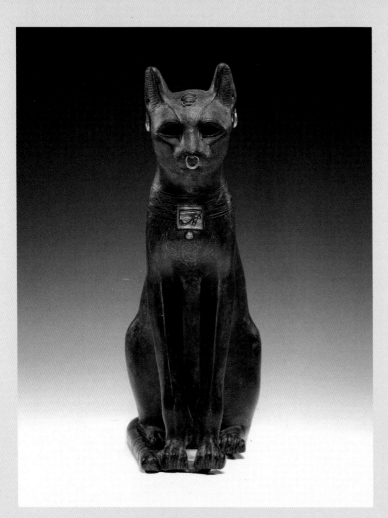

The ancient Egyptians' attachment to cats is well known. They worshipped feline deities, such as Bastet, and often buried mummified cats in their tombs. They associated the animal with qualities of fertility and motherhood, partly due to the care that it takes of its young, and also, judging by this sculpture, valued its grace and beauty.

Exquisite as it is, this figure lacks the tactile softness of Samuel Howitt's early 19th-century pet. The Egyptian cat has a formal, symmetrical pose and is covered in symbols of rebirth and immortality, above all the scarab beetle, which appears on its forehead and below its collar. Unlike more modern cat-lovers, the Egyptians were not sentimental about their animals, which were raised in order to be sacrificed as votive offerings.

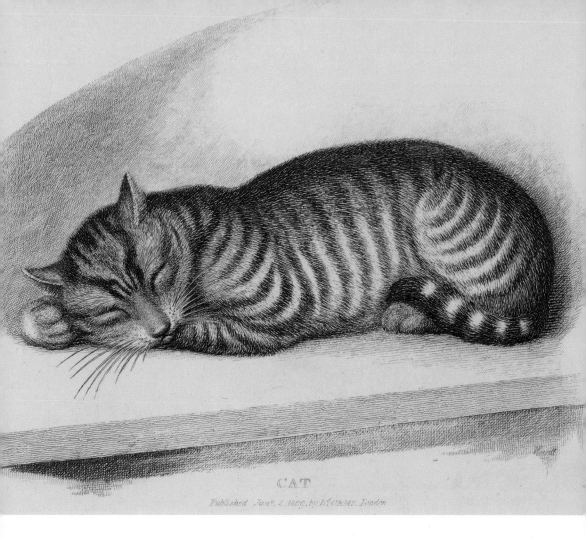

CAT

Published Jan.ᵉ 2 1809, by E. ORME London.

Cat
Samuel Howitt (1756–1822)
1809
British
Etching
H 16.5 cm, W 21.5 cm

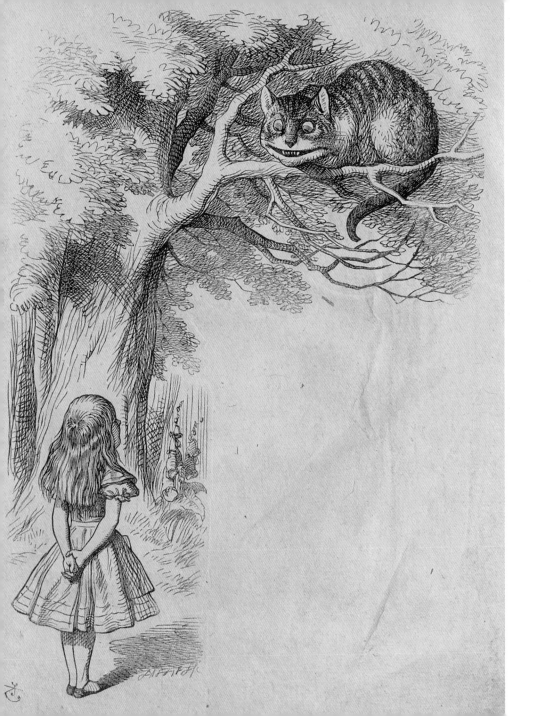

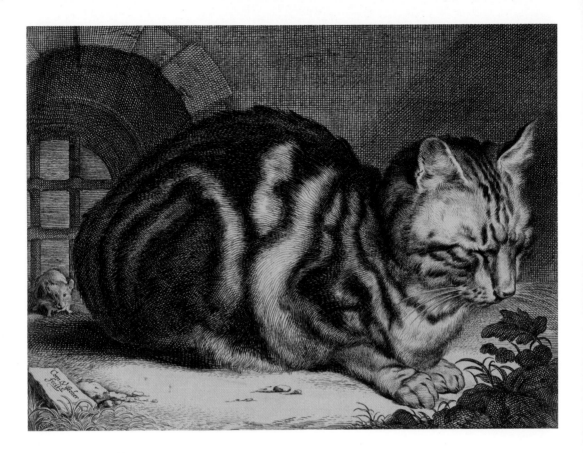

OPPOSITE

*Alice's Adventures in
Wonderland* from 'India-Proofs
of Wood-Engravings by
The Brothers Dalziel'
Dalziel Brothers (1839–1905),
after Sir John Tenniel (1820–1914)
1865
British
Wood engraving
H 45.3 cm, W 29.2 cm

ABOVE

The Large Cat
Cornelis Visscher (1628/9–1658)
c. 1657
Dutch
Engraving
H 13.9 cm, W 18.4 cm

'The Cat only grinned when it saw Alice. It looked
good-natured, she thought: still it had *very* long claws
and a great many teeth, so she felt that it ought to be
treated with respect.'

Sir John Tenniel's illustration perfectly captures the
menace that lurks behind the smile of Lewis Carroll's
Cheshire Cat. The over-sized animal is, of course, a
character in Wonderland – 'we're all mad here', as he
tells Alice – but violence is always latent in the feline
world. Cornelis Visscher's cat may be sensual to touch,
but the mouse cowering in the dungeon-like setting
expresses a feeling of terror.

Sacrifice and Ceremony

Who are these coming to the sacrifice?
To what green altar, O mysterious priest,
Lead'st thou that heifer lowing at the skies…?

John Keats' lines, although addressed to an ancient
Greek vase in one of his most famous odes, actually
describe this relief from the Parthenon in Athens, with
the heifer shaking its head on its way to slaughter.
The scene is part of the quadrennial Panathenaic
festival, which took place in honour of the goddess
Athena and included a long procession of horses.
Despite the unrealistic scale of the riders in relation
to their mounts, there is a convincing sense of
excitement, with the horses barely kept under control.

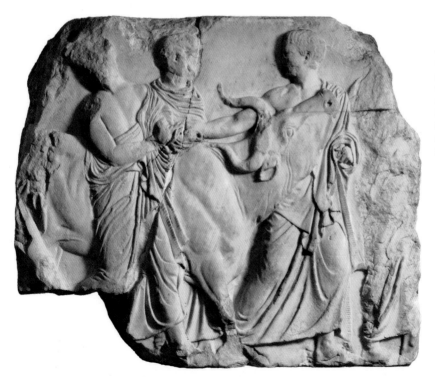

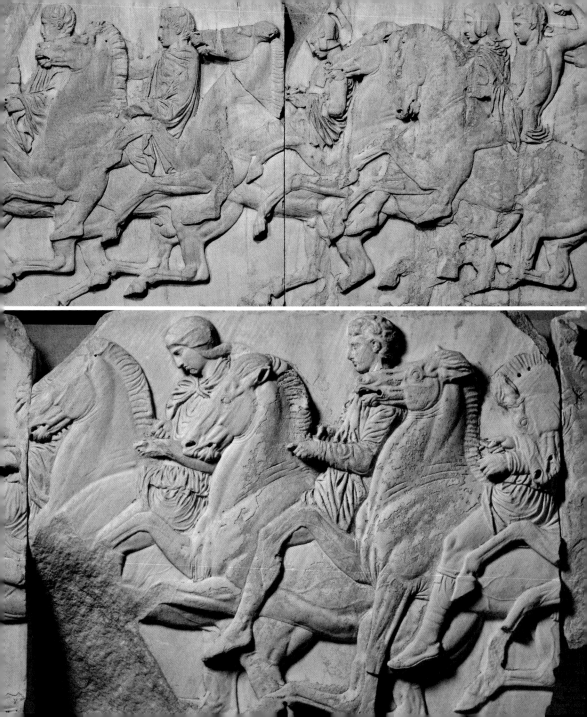

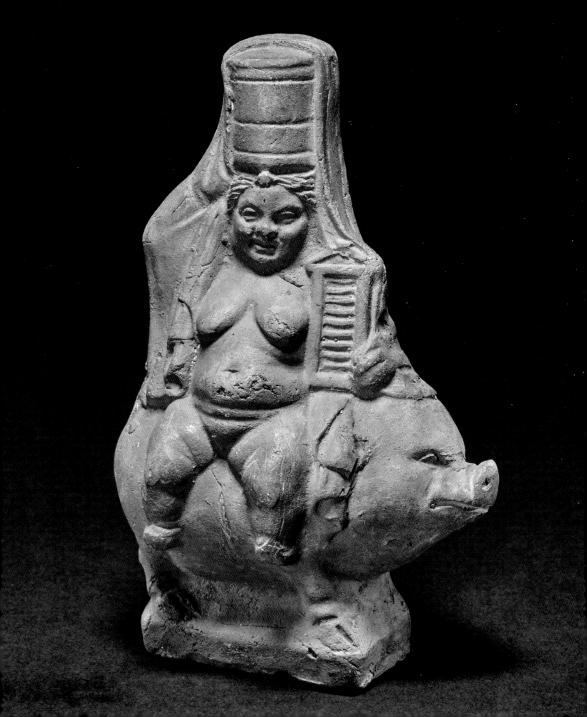

OPPOSITE
Figure of a woman riding a pig
Greek, 1st century BC
Made in Egypt
Excavated in Fayum, Egypt
Teracotta
H 13.8 cm

BELOW
Figure of a pig
Roman, 1st century BC–1st
century AD
Made in Italy
Found near Rome
Bronze
H 2.5 cm

Pigs often suffered as ritual victims in the ancient world. The Roman bronze sculpture shows an animal garlanded for sacrifice, while the Hellenistic terracotta depicts a devotee of the Greek goddess Demeter riding on a pig and carrying a *kiste*, or sacred chest. Though obscure, its contents must have related to the legend of Demeter and her daughter Persephone, who was obliged to stay with Hades, the god of the Underworld, for six months every year before returning to Earth. Demeter and Persephone were the object of mysterious rituals, such as those held at Eleusis in Attica every spring, in which the terracotta pig was doubtless destined for slaughter.

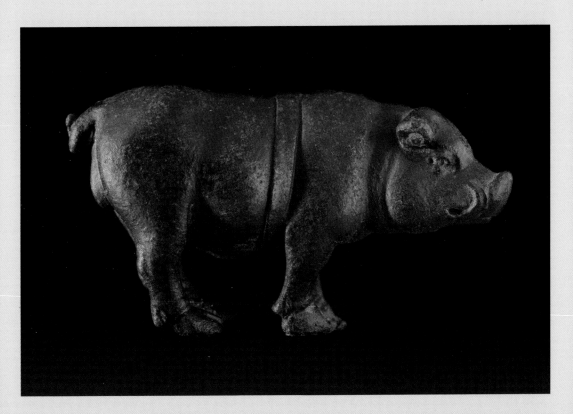

Cattle began to be domesticated several millennia
before the creation of these sculptures, in which men
strive heroically with bulls. Mithras and the Bull was
a legend of Persian origin that became highly popular
throughout the Roman Empire. In slaying the bull, the
god sheds its blood, which regenerates life and light.
This connection between sacrifice and fertility is
emphasized by the scorpion next to the bull's genitals,
while the dog and snake gain nourishment from
licking its wounds.

Statue of Mithras slaying a bull
Roman, 2nd century AD
Excavated in Rome, Italy
Marble
H 129 cm

Bronze Group of a Bull
and Acrobat
c. 1600–1450 BC
Made on Crete, Greece
Bronze
H 11.4 cm, L 15.5 cm

A slightly kinder treatment of the bull is suggested in
this bronze from Minoan Crete. An acrobat jumps over
the head of the creature, which has lost its hind legs,
in order to land standing on its back. Although we
know little about this practice, it is likely that it also
had a religious dimension and, for all its apparent lack
of violence, it may have led to the eventual sacrifice
of the bull. Such is the power of this animal that the
act of dominating or even destroying it is a recurrent
theme in art.

— 3 —
EXOTIC

THE HISTORIAN HERODOTUS WROTE how the Persian forces of King Xerxes – or at least their camels – were attacked by lions as they invaded Greece in the early 5th century BC, but he also described the limits to their range. The European lion was already a species in decline: clearly the creator of the strange version on page 114 had never seen one in the flesh.

Tigers crossing a river (detail)
See page 117

Many images of 'exotic' animals – the unfamiliar, the colourful and the unexpected, which people began to encounter in an increasingly connected world – were not based on direct observation. Artists, from Albrecht Dürer to Maruyama Ōkyo, relied on preserved and flayed specimens, other people's impressions or even household pets of related species. This did not prevent their creations from embodying qualities that were appropriate to their settings, whether they were guarding a door or a tomb or simply adding a touch of glamour to an interior, as in the case of the Japanese tigers on pages 116–17.

Even when, more recently, 'exotic' animals became relatively common sights in European cities, they were often represented in fanciful compositions or were co-opted by satirists or caricaturists. It must be said that this fate was also met by creatures that are not nearly so outlandish (see page 47). Notwithstanding the odd anatomical inaccuracy based on ignorance, exotic beasts were generally distorted, anthropomorphized and torn from their context in ways quite similar to the liberties artists took with other kinds of animals.

Perhaps the most distinct genre to develop was the explorer's specimen. Precise scientific images of creatures, from tiny invertebrates to ferocious reptiles, were made by Europeans soon after they began to colonize other continents. Admirable as these examples may be, they are not free of artistic stereotypes and conventions (pages 120–21) or ulterior motives. The Elizabethan John White undoubtedly drew some of the animals that he encountered in the 'New World' because he was interested in eating them. Nonetheless, many of his striking studies, such as the hermit crab on page 124, convey a sense of disinterested wonder – a desire to understand, rather than consume.

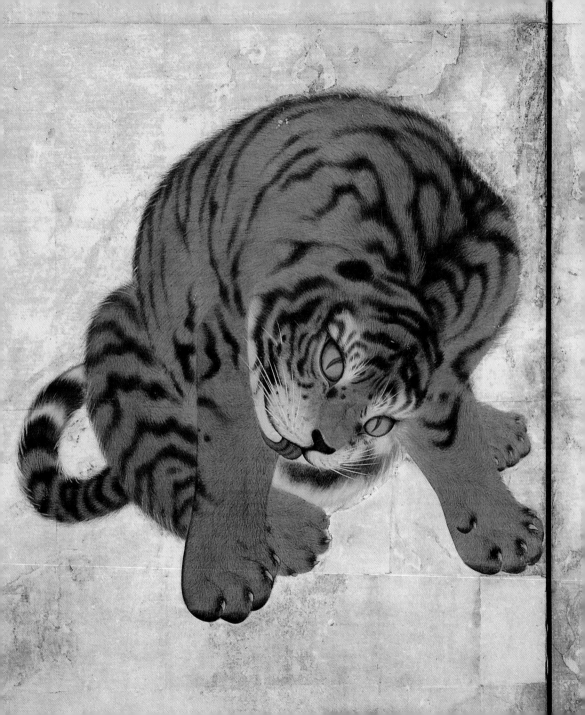

Big Cats

The lion has embodied qualities that have been highly appealing to artists over the centuries, even when they live in countries that are thousands of miles from the animal's natural habitat. The creature lent its strength and nobility to an English Romanesque doorknocker, in the process gaining a human nose, eyebrows and moustache, with its mane decoratively rearranged. But what the lion lost in facial accuracy, the door gained in resilience, or at least the appearance of it.

Door knocker in the form
of a lion's head
c. 1200
Made in England
Bronze
Diam 37 cm

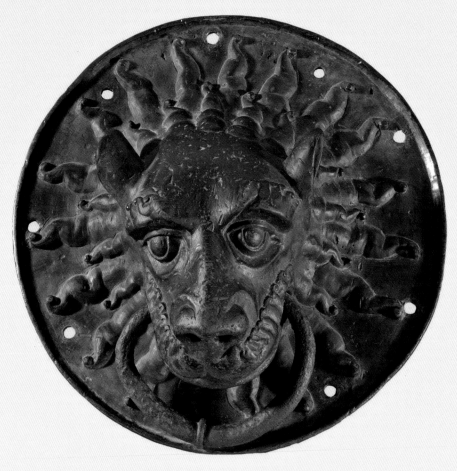

A lion and tiger fighting
James Ward (1769–1859)
1799
British
Mezzotint
H 48.3 cm, W 60.7 cm

Over six centuries later, the English painter James
Ward depicted the ferocity of the lion, creating a beast
that is convincing in its anatomy if not its context.
The cavernous setting has a Romantic grandeur but
little resemblance to the savannah, while the adversary
is another species of big cat, which the lion would
never encounter in the wild.

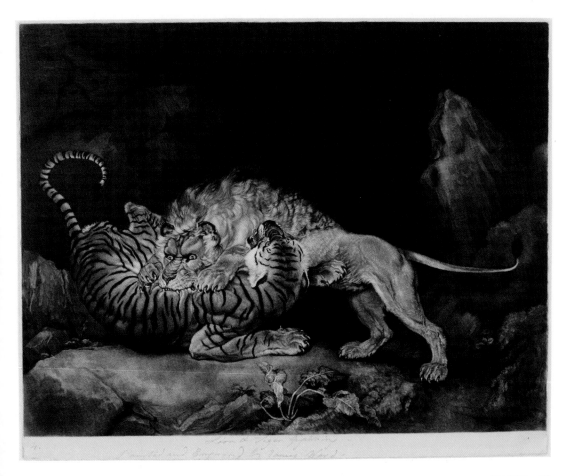

The ancient Greeks' knowledge of lions was somewhat inconsistent. This is not surprising as during antiquity the lion gradually became extinct in the eastern Mediterranean. The Lion of Knidos, which sat on the top of a funerary monument on the coast of Asia Minor (Turkey), is a relatively accurate depiction. It must have been especially impressive in its original setting, with its eyes, once inlaid with glass, flashing in the sun.

In contrast, the bronze beast, which was probably once a fitting for furniture, has both teats and a mane, and is preparing to pounce with its rear end raised like a dog. So convinced were the Greeks that lions adopted this pose that they used leonine, rather than canine, imagery to describe human sexual positions. For this reason they even gave prostitutes the nickname 'lionesses'.

Figure of a crouching lioness
Greek, 6th century BC
Found on Corfu, Greece
Bronze
H 10.16 cm

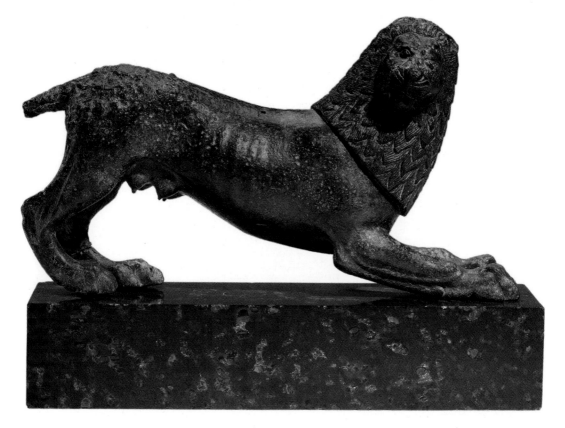

Colossal statue of a lion
Greek, 2nd century BC
Excavated in Knidos, Turkey
Marble
H 182 cm, L 289 cm

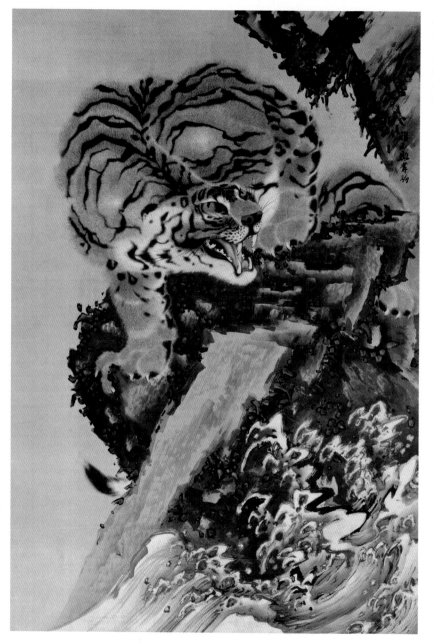

Snarling tiger
Kishi Ganku (1749–1838)
c. 1790–1838
Japan
Hanging scroll, ink and colour
on silk
H 169.3 cm, W 114.6 cm

Tigers were a luxury commodity for these Japanese painters rather than a species that they had actually encountered. Despite his brilliant depiction of fur, fangs and even whiskers, Kishi Ganku has represented the animal with a flattened, artificial anatomy. This is a rug, not a real creature, a flayed skin into which the artist has breathed a kind of life as it roars on a rock above gushing waters.

Maruyama Ōkyo, who created an equally powerful image of tigers crossing a river, was known for his observation of nature. Even he, however, had to draw on a combination of skins and domestic cats in order to concoct this fantasy of the wild.

Tigers crossing a river
Maruyama Ōkyo (1733–95)
1781–82
Kyoto, Japan
Six-panel folding screen, ink, colour and gold-leaf on paper
H 153.5 cm, W 352.8 cm

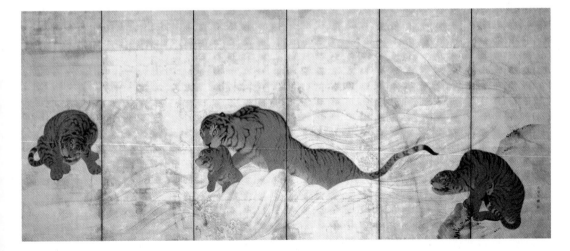

'Bacchus and his pards', as John Keats describes them in his 'Ode to a Nightingale', were common themes in antiquity, with a rich afterlife in later European culture. As the god of wine, Bacchus is shown dancing with a panther or leopard in this mosaic from Halicarnassus, where he is identified under his Greek name, Dionysus. The sense of wild abandon is noticeably absent from the Bow Factory porcelain figures, in which the god sits on a feline that looks like an overgrown pet. As in the mosaic, Bacchus is crowned with vines, which he appears to be feeding to his companion, but there the resemblance to antiquity, or indeed Keats, ends.

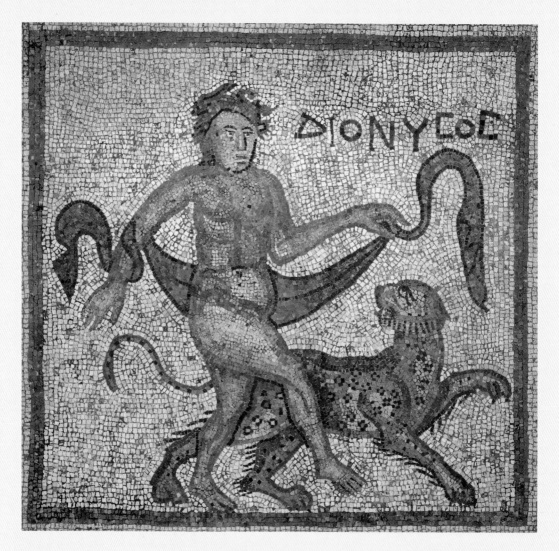

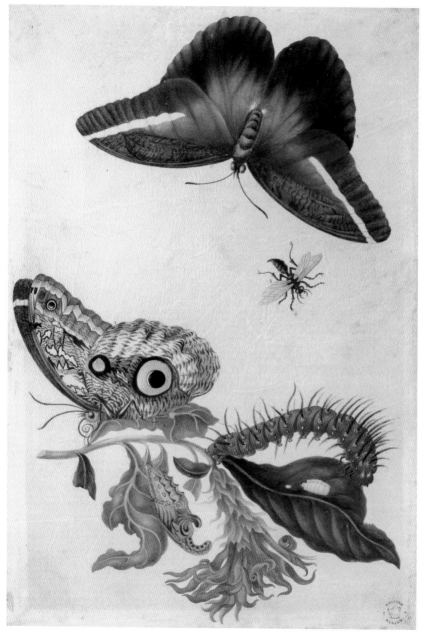

LEFT
Drawing of butterflies
Maria Sibylla Merian (1647–1717)
c. 1701–5
German
Watercolour with pen and black ink
H 36.1 cm, W 24.6 cm

OPPOSITE
Drawing of a tiger swallowtail butterfly
John White (*c.* 1540–93)
c. 1585–93
British
Watercolour over graphite
H 13.9 cm, W 19.8 cm

Explorers' Specimens

John White, who first travelled in 1585 to Sir Walter Raleigh's settlement in 'Virginia' (now part of North Carolina), created the earliest known picture of a butterfly in America. Although White brought the odd insect specimen back to England, it was principally through his watercolours that he recorded, with great accuracy, the animals he encountered.

A century later, in 1699, the city of Amsterdam sponsored the artist and naturalist Maria Sibylla Merian to make a scientific expedition to Suriname, a Dutch colony in South America. After her return to Holland two years later, she published *Metamorphosis insectorum Surinamensium*, which, as the title suggests, included precise representations of the different stages in a butterfly's life. Today Merian is regarded as one of the pioneers of entomology.

LEFT

Drawing of a caiman wrestling with a red and black snake
Attributed to Dorothea Graff
(1678–1743)
c. 1701–5
German
Watercolour with pen and ink
H 30.6 cm, W 45.4 cm

BELOW, LEFT

Scene from the Gazi Scroll
c. 1800
Bengal, perhaps the Murshidabad district, India
Painted on paper
L 13 m (scroll)

Dorothea Graff, the daughter of the naturalist Maria Sibylla Merian, has shown both these South American creatures in the act of biting a coral snake. Despite the use of these stock poses, she has shown close attention to anatomical detail, colour and texture.

A more stylized approach towards crocodilians can be seen in the Indian scroll painting, although the exaggerated curvature of the body is analogous to that of Graff's caiman. The beast is a character in the adventures of Gazi (see also page 79) as one of the animals over which the holy man exercised superhuman mastery.

Drawing of a blue and yellow
parrot
Attributed to Dorothea Graff
(1678–1743)
c. 1700–10
German
Watercolour
H 50 cm, W 36.4 cm

Caracol.

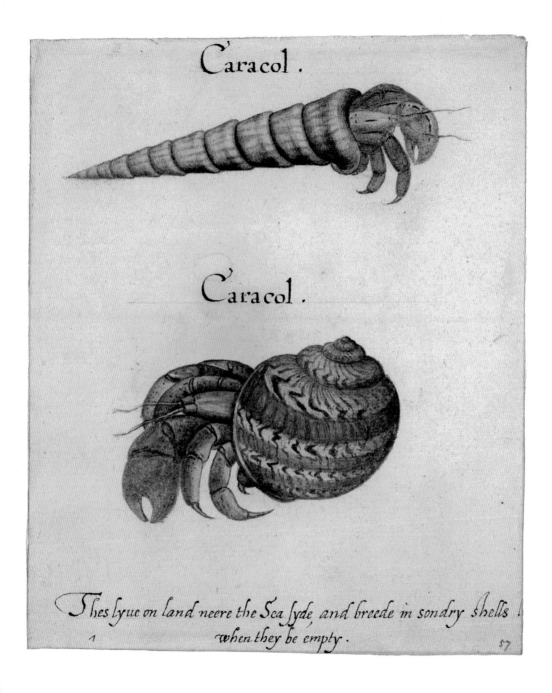

Caracol.

Thes lyue on land neere the Sea syde, and breede in sondry shells
when they be empty.

1 57

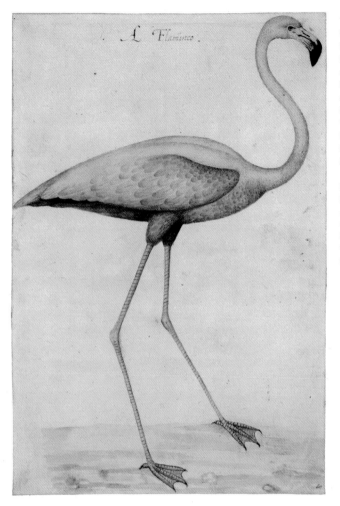

L Flamingo

The Greater Flamingo was probably seen by John White in the Caribbean or the Bahamas on his way to the English settlement of Virgina. His watercolour has been admired by ornithologists for its detailed depiction of the bird's plumage. Even more remarkable is the hermit crab, which climbs for protection into the empty shells of molluscs: 'caracol' in Spanish can be translated as 'sea-shell'. Hermit crabs are inedible, and White seems to have been interested in both these creatures as exotic specimens rather than as sources of food, although practical considerations did motivate some of his other drawings.

LEFT

Drawing of a flamingo
John White (*c.* 1540–93)
c. 1585–93
British
Watercolour over graphite
H 29.6 cm, W 19.7 cm

OPPOSITE

**Drawing of purple-clawed
(or land) hermit crabs**
John White (*c.* 1540–93)
c. 1585–93
British
Watercolour over graphite
H 18.8 cm, W 15.5 cm

Outlandish Animals

Outlandish animals with tusks and horns have inspired countless objects, although many were made by artists who had never seen the beast in question. Dürer's rhinoceros was inspired by the fame of a creature that had been sent to the Pope by the King of Portugal but was lost at sea off La Spezia. The image was based on a sketch made by a merchant when the creature arrived in Lisbon from the East Indies. Dürer tried his best with the rhino's head and horn, but gave its appendages almost reptilian scales and body armour.

Rhinoceros
Albrecht Dürer (1471–1528)
1515
German
Woodcut and letterpress
H 21.2 cm, W 29.6 cm

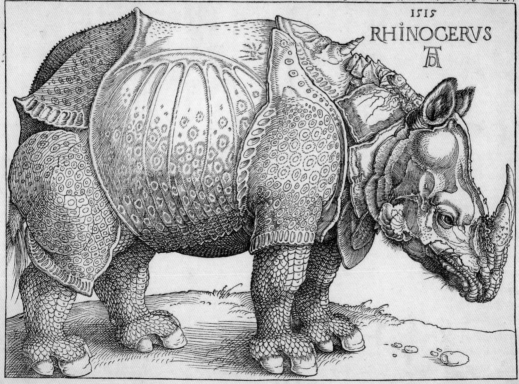

These two porcelain elephants, made by Japanese craftsmen and possibly based on pictures from India, have eyes that recall the features of the men who created them more than any actual animal. Fortunately, the Westerners who acquired these artefacts probably cared little about zoology. They were interested, above all, in the virtuosity of the enamel decoration and white glaze, which has a pallor and smoothness that is hardly elephantine but enhanced the figures' allure.

Pair of model elephants
c. 1655–70
Hizen ware, Arita kilns, Japan
Porcelain
H 35 cm, W 42 cm (left); H 35 cm,
W 43.5 cm (right)

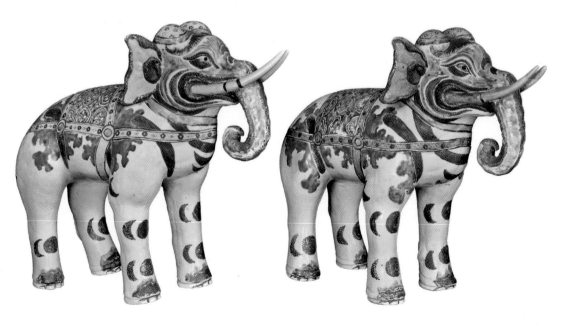

The walrus is an Arctic animal, prized for its ivory tusks, that was sometimes found on the Norwegian coast and more rarely further south. It would have seemed very exotic to Dürer, a citizen of Nuremberg, a landlocked city. His compelling watercolour includes his own improbable description: '1521. That stupid animal…was caught in the Netherlands sea and was twelve brabant ells long with four feet.'

Dürer had himself visited the Netherlands in 1520–21, though his diary makes no reference to a walrus and, tellingly, his image is just of the animal's head. Two years earlier, a bishop in Norway had pickled a walrus's head and sent it to Pope Leo X, whose collection also included an Indian rhino. It seems likely that Dürer was working with a preserve.

Drawing of a walrus
Albrecht Dürer (1471–1528)
1521
German
Pen and brown ink
H 21.1 cm, W 31.2 cm

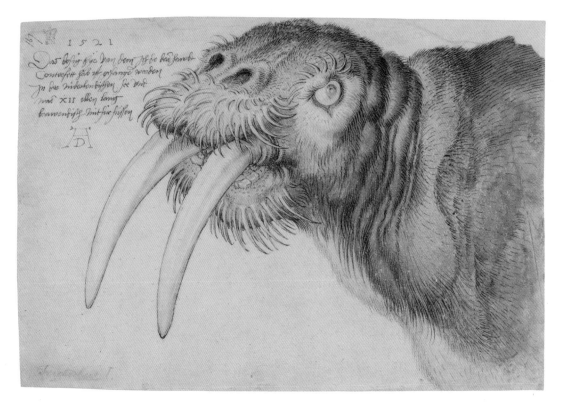

Walruses certainly came with a reputation. Jan Luyken's turbulent etching refers to the Dutchman Willem Barentsz's Arctic exploration of 1594, but is far from being a first-hand account of the journey. It is actually based on depictions of the Biblical story of Jonah and the Whale.

Tocht naer Nova Zemla in den Jaere MDXCVI (Expedition to Novaya Zemlya in the year 1596 [1594])
Jan Luyken (1649–1712)
c. 1679
Dutch
Etching
H 27.2 cm, W 34.5 cm

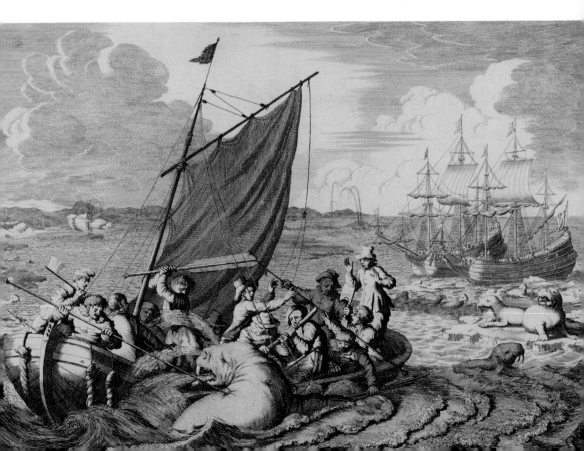

The Human Zoo

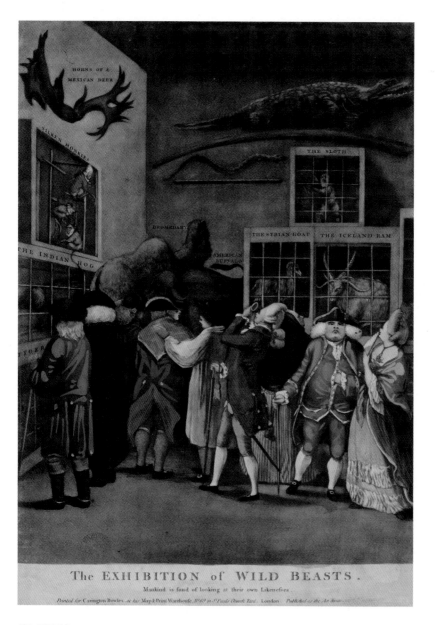

The EXHIBITION of WILD BEASTS.

Mankind is fond of looking at their own Likenesses.

Printed for Carington Bowles, at his Map & Print Warehouse, N°69 in S¹ Pauls Church Yard, London. Published as the Act directs

LEFT
The exhibition of wild beasts
Anonymous
1774
British
Hand-coloured mezzotint
H 35 cm, W 25 cm

OPPOSITE
Crocodile and hippopotamus hunt
Willem de Leeuw (1603–c. 1665)
after Peter Paul Rubens
(1577–1640)
c. 1623–24
Flemish
Etching
H 46.5 cm, W 64.1 cm

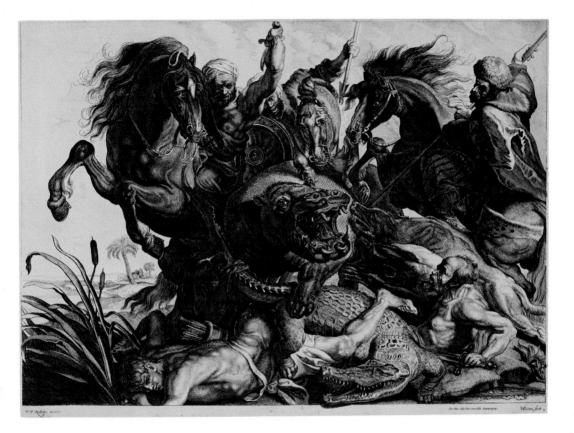

By the 18th century, many exotic creatures could be viewed in the bare, cramped cages of a European menagerie. The human zoo that flocked to see these spectacles was at least as interesting, as can be seen in the anonymous satirical print from the 1770s. The man and the monkey exchanging glances are dressed and bewigged in exactly the same way. As the legend beneath puts it, 'Mankind is fond of looking at their own Likenesses.'

The print of a hippopotamus hunt, based on a composition by Rubens, may also be intended to reflect man's bestial qualities. Although these darker instincts, represented by the hippopotamus and crocodile, are apparently being vanquished, the atmosphere is ambiguous and disturbing. While drawing on classical imagery of Nile animals, Rubens probably based his hippo on stuffed specimens that he saw in Rome.

Ostrich feathers, and the ridicule directed at their wearers, are a common feature of these images. The subtitle of 'The Feather'd Fair in a Fright' suggests that the maidservants who have stolen these decorations should 'restore the borrowed plumes', but the appearance of the ostriches reminds us that it is they, not the women's employees, who are the rightful owners. The satire is made more pointed by the Biblical description of the birds as themselves lacking wisdom and understanding.

The absurdity continues in William Heath's etching, where the grotesque George IV and his mistress, Lady Conyngham, contrast with the slender giraffe or 'camelopard' sent to England in 1827 by the pasha of Egypt. The creature is ostensibly the new 'hobby' but, as so often, the animal reflects the moral failings of the humans it accompanies. Like the giraffe, Lady Conyngham is herself a passing royal fashion.

RIGHT

The Feather'd Fair in a Fright
After John Collet (*c.* 1725–80)
1777
British
Hand-coloured mezzotint
H 34.7 cm, W 25.1 cm

OPPOSITE

The camelopard, or a new hobby
William Heath (1794–1840)
1827
British
Hand-coloured etching
H 33.2 cm, W 22.4 cm

The FEATHER'D FAIR in a FRIGHT.
From the Original Picture by John Collet, in the possession of Carington Bowles.

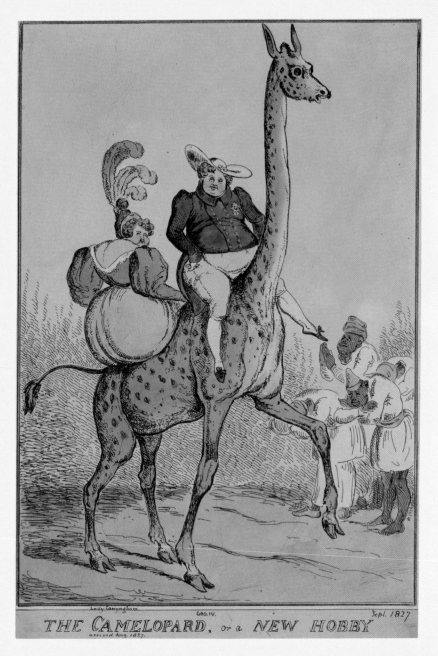

Lady Conyngham Geo. IV. Sept. 1827

THE CAMELOPARD, or a NEW HOBBY
arrived Aug. 1827.

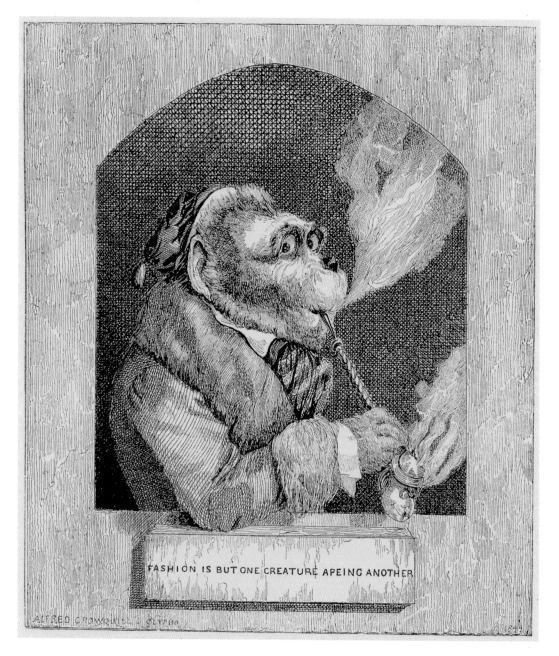

FASHION IS BUT ONE CREATURE APEING ANOTHER

ALFRED CROWQUILL - GLYPHO.

In late Victorian England, the Martin Brothers were renowned for their unique Arts and Crafts ceramics, which often took the form of tobacco or storage jars in the guise of grotesque birds. Their anatomies were derived from both domestic and exotic species, such as vultures, but they were given leering human expressions, apparently modelled on actual people. The effect was both macabre and satirical.

Satire was also the aim of the image by English illustrator Alfred Henry Forrester, whose subject nonchalantly rests his elbow at the edge of a window, like an aristocrat in a Renaissance portrait. A picture of elegance with his pipe and fur collar, he is also, of course, a monkey and, like so many simian characters, reflects our own vanity and folly. After all, 'fashion is but one creature apeing another'.

OPPOSITE
A monkey dressed as a man
After Alfred Crowquill (Alfred
Henry Forrester, 1804/5–72)
1844
British
Glyphograph
H 12 cm, W 10.5 cm

RIGHT
Tobacco jar of a grotesque bird
Made by the Martin Brothers
1882
London, England
Stoneware
H 53.5 cm

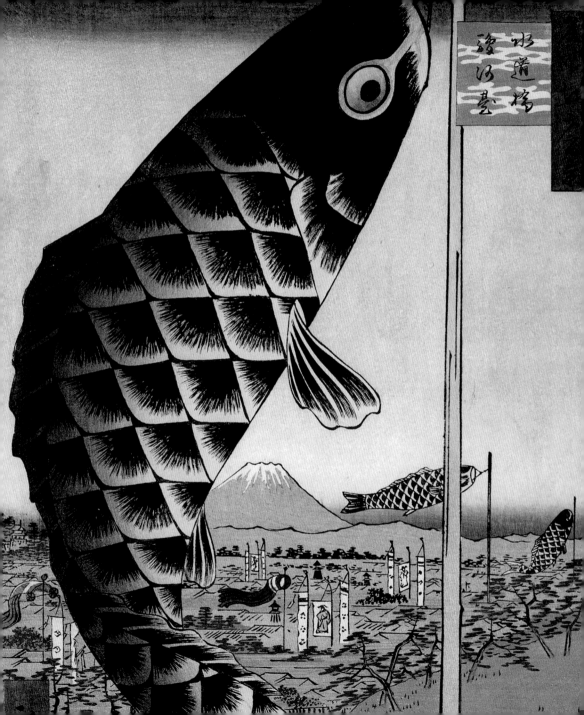

— 4 —

SYMBOLIC

A SYMBOL CAN BE ANYTHING: an abstract form or colour; a flower; a person — and, of course, an animal. Some beasts, for example the Chinese phoenix (opposite), are regarded as auspicious, in this case symbolizing a harmony of female and male elements. Lions, as we have seen, are almost universally associated with fortitude, strength and nobility. This section explores images that carry even more specific meanings, standing for a particular individual, such as St Mark the Evangelist (page 132), or representing the office of pharaoh (pages 134–35).

The ancient Egyptians did not connect kingship solely with leonine qualities of ferocity and valour. As in many cultures, their rulers had a religious role, in which the achievement of immortality was symbolized by the snake that adorned their brow, with its ability to shed its skin apparently in eternal youth. The serpent carried far more negative associations in the Judaeo-Christian tradition. It is, after all, the agent of Man's Fall in the Bible (page 140). Even in Egypt, the snake served in funerary art as a representation of the danger that one might meet in the afterlife. This is certainly a lot of meanings for one sub-order of reptiles to convey.

Meanings shift as context changes. The unicorn, with its single horn, could be a symbol of masculinity, but, connected with the theme of sacrifice, it became pre-eminently an emblem of purity and the resurrected Christ (pages 186–87). Animals may be consistently associated with a particular quality, but the moral significance of this may vary between different cultures. The sexual energy of goats has been widely recognized, but while Christian Europeans regarded it as sinful, ancient Mesopotamians attributed to it divine, life-giving powers (pages 142–43).

Good and Evil is the theme with which this section begins. It is hard to imagine Goya's macabre animals in *The Sleep of Reason Produces Monsters* as anything but sinister, even as one of the owls offers the artist a tool with which to work, but the birds associated with the goddess Athena clearly had different connotations (pages 146–47). To ascribe a precise morality, a calibration on the scale of goodness and badness, is fraught with difficulty in any discussion of ancient cultures. Certain animal symbols have appeared in a wide range of societies, but the values that gave life and colour to these signs are subtle, enigmatic and sometimes obscure.

Pendant in the form
of a phoenix
Liao dynasty, AD 907–1125
Northeast China
Jade
L 7.2 cm

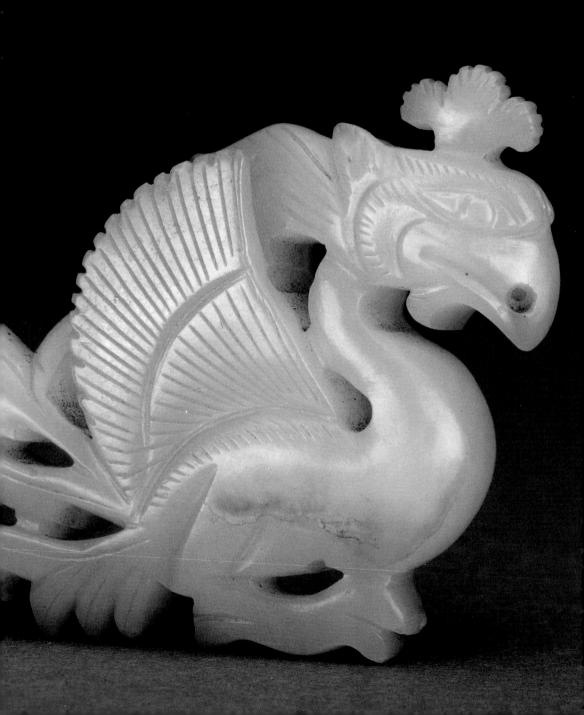

Good and Evil

The Bible has given the serpent a bad reputation. It was he, 'more subtle than any beast of the field which the Lord God had made', who tempted Adam and Eve to eat the fruit from the tree of the knowledge of good and evil.

In cultures not influenced by Genesis' account of the Fall of Man, snakes were associated with rejuvenation and rebirth rather than evil guile, because of their habit of shedding their skin. The ancient Egyptians frequently included images of snakes in their tombs: the bronze cobra on this page was found in Thebes under the shroud of a man called Mentuhotep.

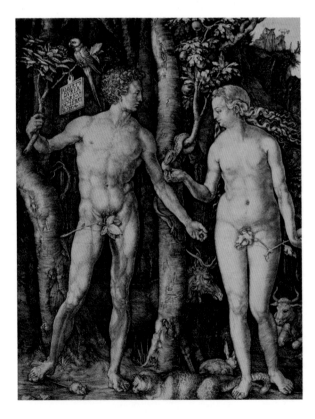

But even in Egypt, the more familiar role of the snake as a natural adversary was represented, for example in the Book of the Dead of Hunefer, a collection of texts placed in the tomb and believed to protect and help the deceased in the afterlife. Here, together with many images of characters wielding knives, a cat disposes of a snake.

Detail from the Book of the Dead
of Hunefer
19th Dynasty, c. 1280 BC
Egypt
Papyrus
L 70 cm, W 46.3 cm

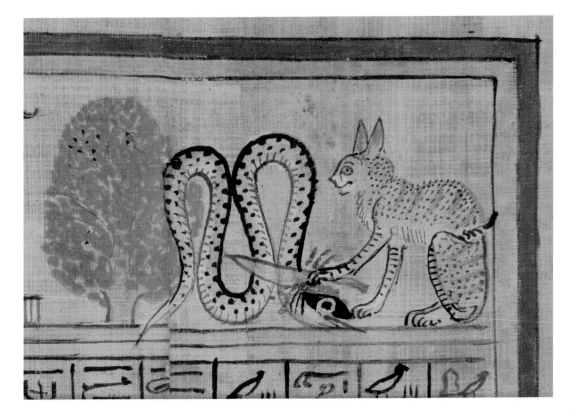

The goat is a primal symbol of the male libido, but the moral significance of this varies in different cultures. In the Dutch artist Hendrik Goltzius's composition, engraved by his stepson, the goat accompanies a female allegorical figure of Lust, one of the Seven Deadly Sins. The figures are visually linked by their physiognomies, the positions of their legs and even by the lascivious curves of their curls and horns. The image brims with energy, but not of the kind that we are supposed to admire.

In contrast, the Sumerian goat, one of a pair from the Royal Cemetery at Ur, is an image of sacred, life-giving forces. The splendid male animal, originally a support for a bowl or tray, rears up behind a plant. Its eight-pointed rosettes are associated with Inanna, the goddess of love, fertility and war. The sculpture is adorned with the richest of materials: silver and gold leaf, perhaps from Iran and Turkey; shell from the Persian Gulf; and, most notably, blue lapis lazuli from Afghanistan. This is a representation not only of divine power but also of the commercial success of Sumerian civilization.

RIGHT

Lust from 'The Vices'
Jacob Matham (1571–1631)
after Hendrik Goltzius (1558–1617)
c. 1587
Dutch
Engraving
H 21.7 cm, W 14.4 cm

OPPOSITE

The Ram in the Thicket
c. 2600 BC
Excavated at the Royal Cemetery,
Ur, southern Iraq
Gilded wood
H 45.7 cm

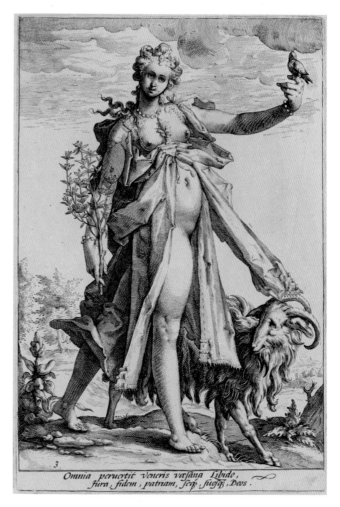

Omnia peruertit Veneris versana Libido,
Iura, fidem, patriam, seq; suosq; Deos.

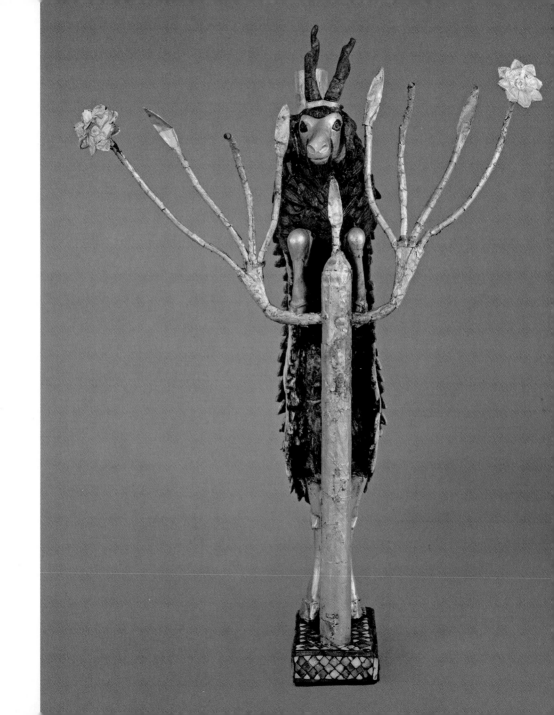

The gandabherunda (or berunda) and the simurgh are mythical birds that were both associated with heroic strength and benevolence. They come from different religious cultures – Hindu and Mughal India respectively – but have many points of comparison, not least a certain similarity to the phoenix (pages 160–63). Here the birds' power is emphasized by showing them in the act of carrying off elephant-like animals. The gandabherunda uses its two heads and claws, while the simurgh has fastened its jaws onto the head of a rukh, which is known in India as a Gaja-Simha (Elephant-Lion) and is itself grasping smaller grey elephants.

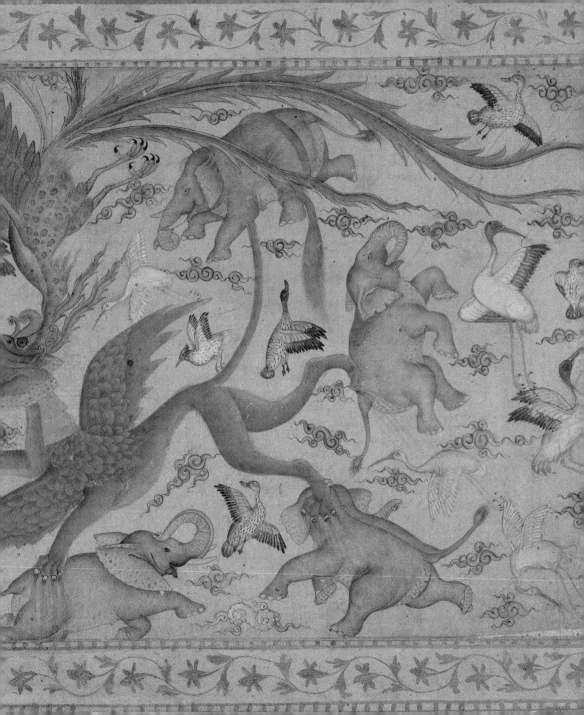

The Spanish master Goya gave his famous print a memorable and revealing title. In the absence of reason, darkness quickly takes over. Goya has made it visible in the form of a lynx and a horde of bats and owls, one of which offers a crayon-holder to the sleeping artist. It is tempting to draw comparisons between these nocturnal symbols of the irrational and the owls accompanying the so-called 'Queen of the Night' from ancient Mesopotamia. This figure, originally red on a black background, may have been a goddess of the Underworld, but her identification, and the significance of her attendants, is uncertain.

We know far more about the Greek divinity Athena, to whom the owl on the 5th-century BC silver coin was dedicated. As she is the goddess of wisdom, and patron of Athens, the owl here has a significance that seems diametrically opposed to that of Goya's birds. Nonetheless, it can be misleading to make a straightforward distinction between good and evil when discussing the morality of the ancient world and its multifaceted gods.

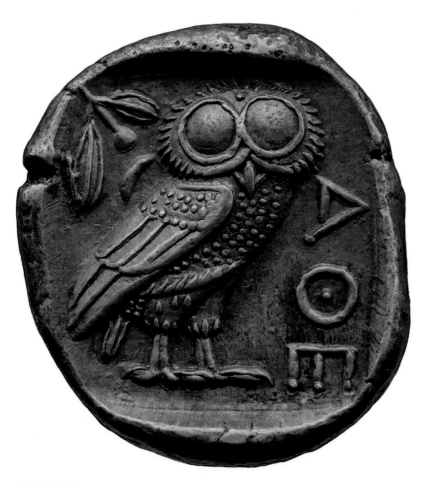

Silver tetradrachm with an owl
(reverse)
527–430 BC
Minted in Athens, Greece
Silver
Diam 2.6 cm

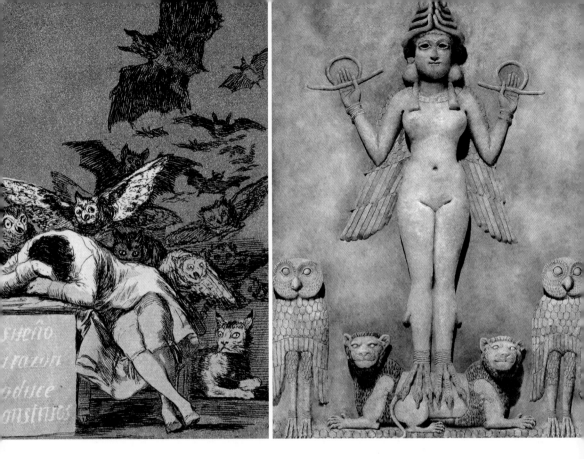

Divinity and Kingship

The Paschal Lamb of God, in Latin 'Agnus Dei', is an
essential symbol of Christ's sacrifice and redemption
of mankind. This image lies at the heart of the Mass,
where it is invoked as the worshippers prepare to take
Holy Communion. It appears, beautifully inlaid with
black niello, in this Italian medallion, with a halo and
the flag symbolizing Christ's resurrection.

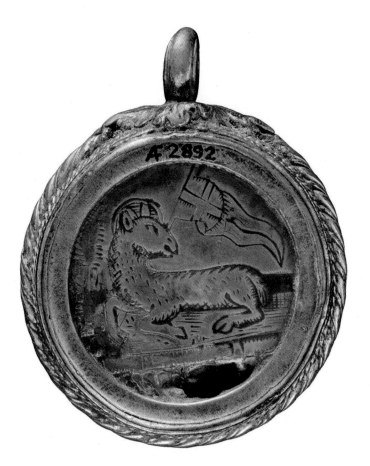

Lamb of God medallion
Date unknown
Made in Italy
Silver, niello and gold
H 4 cm

As a Catholic convert, the Victorian designer Augustus Pugin has incorporated the Lamb into circular tiles, manufactured by Minton in Stoke-on-Trent.

Pugin tile with the Paschal lamb
Designed by Augustus Welby
Northmore Pugin (1812–52)
c. 1845
Made by Minton & Co. Factory,
Stoke-on-Trent, England
Earthenware
L 27 cm, W 27 cm

In the Christian Holy Trinity, God is personified as Father, Son and Holy Spirit. This third element of the Trinity is usually symbolized by a dove, as it is described in the Gospel of St Luke appearing in this form during Christ's baptism.

The dove, in pure white plumage with a halo, is the centrepiece of the gold pendant produced in Rome by Ernesto Pierret, which has a compartment at the back for a lock of hair. The image is made from glass micro-mosaic, a popular medium for jewelry at this time, and is surrounded by the four arms of the cross with letters that spell out the Greek word for 'Victory'.

Carved by Coptic Christians in Egypt, the 8th-century limestone stela includes a cross as well as a dove within a foliate border. The bird, which does not have a halo, stands on scroll-shaped decoration, with a medallion around its neck and its wings outstretched – a powerful, dynamic image of the Holy Ghost.

RIGHT
Gravestone of Mary
c. AD 700–800
Egypt
Limestone
H 134 cm, W 48.8 cm

OPPOSITE
Cruciform pendant with the Dove
of the Holy Spirit
Ernesto Pierret (1826–75)
c. 1860
Made in Rome, Italy
Gold and glass
W 4.65 cm

The great German engraver Martin Schongauer has depicted the Evangelists, the four writers of the Gospels, with the symbols associated with them since Early Christian times. This iconography, which was derived from the books of Ezekiel and Revelation in the Bible, reflects the qualities of each Gospel. While St Matthew, who places particular importance on Christ's human nature and ancestry, is represented by an angel, the other Evangelists are symbolized by animals of different kinds.

RIGHT, TOP
The lion of St Mark from
'The Symbols of the Four Evangelists'
Martin Schongauer (*c.* 1440/53–91)
1469–79
German
Engraving
Diam 8.7 cm

RIGHT, BOTTOM
The angel of St Matthew from
'The Symbols of the Four Evangelists'
Martin Schongauer (*c.* 1440/53–91)
1469–79
German
Engraving
Diam 8.7 cm, H 9.2 cm

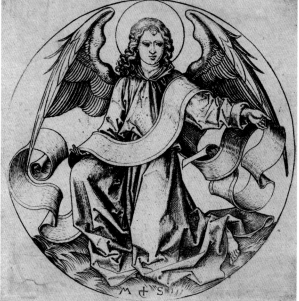

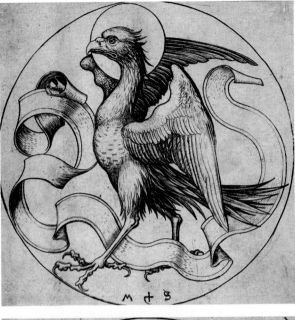

The soaring, visionary nature of St John's writings is conveyed by an eagle, while St Luke is associated with a winged ox, a sacrificial victim, as his Gospel dwells on Christ's atonement for the sins of mankind. The winged lion of St Mark refers to Christ's royal status and his resurrection, on which this Evangelist places great emphasis, as it was believed that lions were born dead before coming to life. St Mark also begins his Gospel with the ministry of John the Baptist, 'the voice of one crying in the wilderness', for which the lion was a fitting emblem.

LEFT, TOP
The eagle of St John from
'The Symbols of the Four Evangelists'
Martin Schongauer (*c.* 1440/53–91)
1469–79
German
Engraving
Diam 8.5 cm, H 8.5 cm

LEFT, BOTTOM
The bull of St Luke from
'The Symbols of the Four Evangelists'
Martin Schongauer (*c.* 1440/53–91)
1469–79
German
Engraving
Diam 8.7 cm, H 8.8 cm

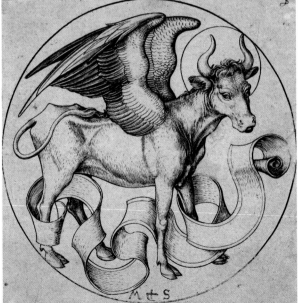

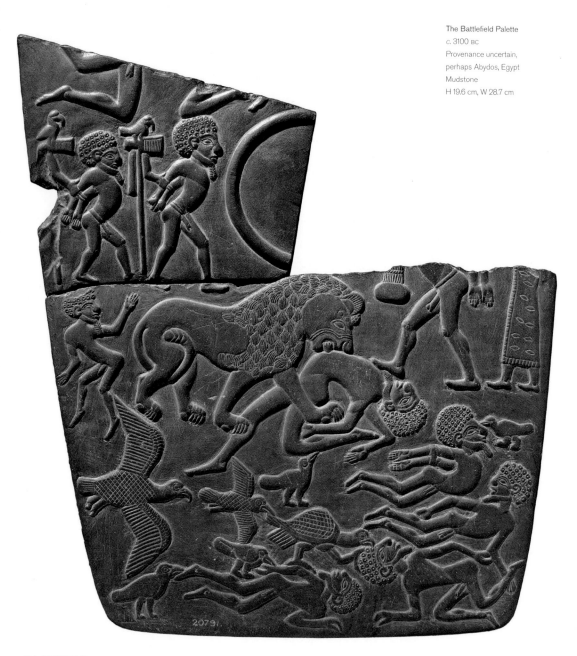

The Battlefield Palette
c. 3100 BC
Provenance uncertain,
perhaps Abydos, Egypt
Mudstone
H 19.6 cm, W 28.7 cm

20791

The Battlefield Palette, from the end of Egypt's prehistoric period, almost certainly uses the lion as a symbol of a king defeating his enemies. One naked man is slaughtered by the magnificent maned creature, while elsewhere corpses are pecked at by birds in different scales, probably vultures and crows.

As deified 'Lords of Nubia', the pharaohs of the 18th Dynasty were symbolically represented, like their predecessors, as lions. However, this massive example, from Soleb, north of the Nile's Third Cataract, exploits the nobility of the animal at rest. The lion, which would originally have had inlaid eyes, creates a strong sensation of power, notwithstanding the stylization of its ruff-like mane and angular body. As one of a pair, the sculpture would originally have guarded a temple constructed by Amenhotep III, though it may have been made for his son, Akhenaten.

One of the Prudhoe Lions
18th Dynasty, c. 1370 BC
Gebel Barkal, Sudan
Red granite
H 117 cm, L 216 cm

Birds have often been used as symbols of royalty. The Benin staff is unusual in referring to a bird that was killed by the Oba, or king, Esigie in the 16th century in order to avoid the defeat it had prophesied. Every year the beak of this idiophone was struck, like a bell or a gong, in order to demonstrate that the king always has the last word.

In general, avian symbols draw more obviously on the appearance of the bird and the qualities that this suggests. The double-headed eagle, for example, not only conveys a sense of power but also, in looking two ways, represents the vast extent of imperial authority. The image was associated since the Middle Ages with the Holy Roman Empire, though it originated in antiquity and was also used by Byzantine rulers. In the German artist Hans Burgkmair's woodcut, the creature shelters an image of the enthroned Maximilian I above a fountain adorned with the Muses and other allegorical and mythological figures.

OPPOSITE, LEFT

Aquila Imperialis (The Imperial Eagle)

Hans Burgkmair the Elder
(1473–1531)

1507

German

Woodcut

H 35.2 cm, W 25 cm

OPPOSITE, RIGHT

Musical instrument, idiophone, in the form of an ibis-like bird

c. 1700–1800

Benin City, Nigeria

Brass

H 32.5 cm, W 11 cm

BELOW

Dunstable swan jewel

c. 1400

Made in France or England

Gold and enamel

H 3.4 cm

Swans have quite different associations, suggesting courtly values of chastity and chivalry, typified by the Swan Knight of medieval literature. They were used as emblems by certain aristocratic families, and were associated in particular with the Prince of Wales after the seizure of the English Crown in 1399 by Henry of Lancaster. The example here is a livery badge probably meant to symbolize allegiance to the House of Lancaster.

In classical mythology the peacock, that most regal of birds, was the attribute of Juno, the queen of the gods. She adorned its tail with the hundred eyes of the watchman Argus, who was foolish enough to be lulled to sleep by Mercury while supposedly guarding the goddess' love rival, Io, in the form of a white heifer. Together, the bird and his mistress are fitting subjects for Jean Limousin's luxurious enamel.

Engraved decorations on the steel peacock, from the period of the Qajar dynasty in Iran, combine hunting scenes with the figure of the enthroned Solomon. Deftly representing this combination of courtly pursuits and faith, the peacock may have adorned the crossbar of an alam, a standard carried during religious processions.

RIGHT
Peacock standard or alam
19th century
Iran
Steel, engraved with some gilded
and gold overlay
H 89 cm

OPPOSITE
Painted Limoges enamel
salt-cellar
Attributed to Jean Limousin
or Joseph Limousin
c. 1600–30
Made in Limoges, France
Enamel, gold and copper
H 9.1 cm, Diam 12.5 cm (base)

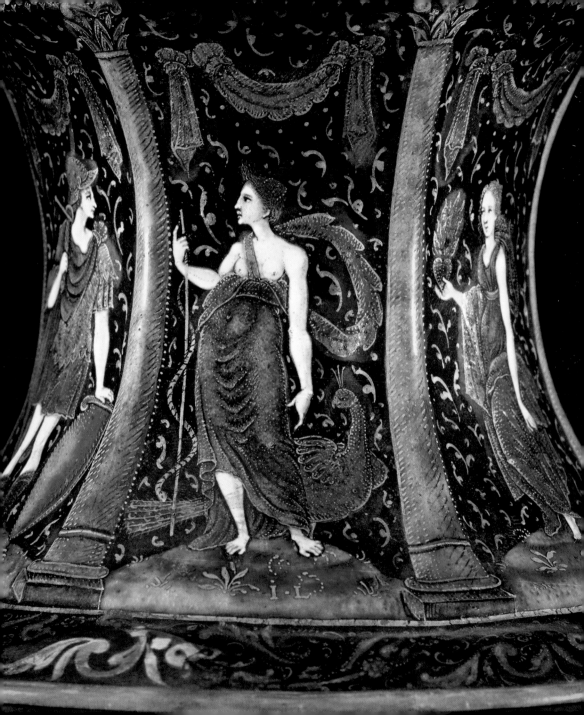

A bird that lives to a great age before it is consumed by fire and reborn from its ashes, the phoenix is also the only one of its kind alive at any time. As such it is a mythical creature charged with symbolic meaning. Its uniqueness and longevity, its capacity for resurrection and immortality, and the chaste manner of its regeneration clearly recommended it to Elizabeth I, the Tudor Queen of England. She was, after all, a monarch, renowned for her virginity, who was convinced of her divine right to rule and reigned for almost half a century.

The Phoenix Jewel
c. 1570–80
Made in England
Gold and enamel
H 4.9 cm, W 4.4 cm

The phoenix played an important role in images of
Elizabeth, not least in this famous gold pendant with
a relief of the bird in flames on the reverse of the
queen's bust. Placed beneath her monogram, crown
and heavenly rays, the creature is enclosed within
a beautifully enamelled wreath of red and white
Tudor roses.

The phoenix also appears on the back of a silver medal dedicated to the Queen, exemplifying the popularity of this symbol in Elizabethan iconography. However, the legendary bird was not confined to 16th-century England. Its origins lie in antiquity, and a version of it was also very popular in Chinese imperial imagery. A Qing Dynasty dish, for example, shows four ladies on a terrace watching a couple, probably the Emperor and Empress, riding a dragon and a phoenix into the heavens. Bordered by clouds and medallions with storks, this is a lyrical image of two creatures that were associated with the Emperor and symbolized a harmonious combination of male and female aspects.

BELOW

Cast silver medal with the bust of Elizabeth I (obverse, right) and a phoenix amid flames (reverse, left)
1574
Made in the British Isles
Silver
H 4.7 cm, W 4.1 cm

OPPOSITE

Dish with a scene depicting a man riding a dragon and woman on a phoenix below a moon and stars
Qing Dynasty, 1662–1722
Jingdezhen, China
Porcelain and gold
Diam 36.7 cm

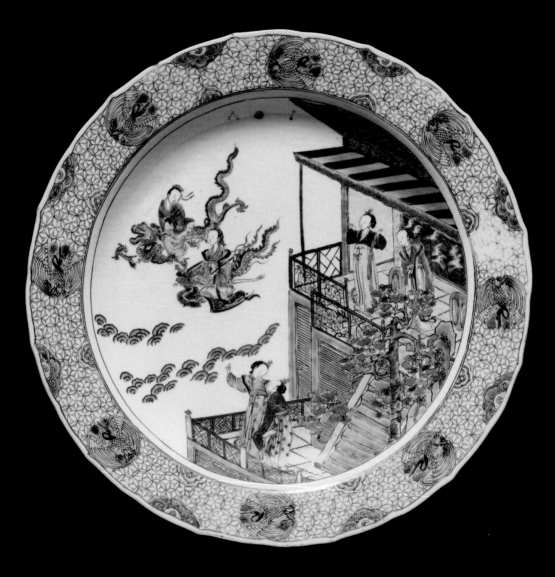

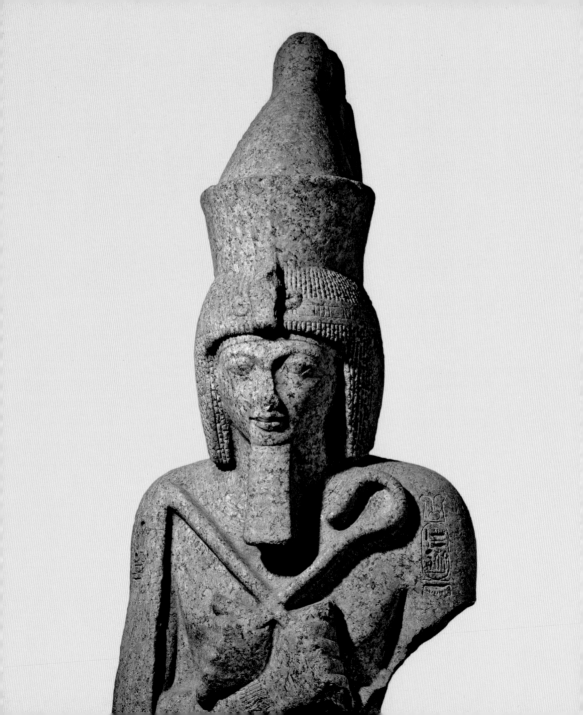

Rulers in various cultures have tried to harness the rejuvenative power embodied by the snake (see pages 140 and 166). It appeared as the uraeus, or symbol of kingship, that adorned the crowns of the Egyptian pharaohs (see page 196). The crown of Lower Egypt is worn here by a gilded, rearing cobra, which may be an image of the goddess Wadjet, herself the divine embodiment of Lower Egypt. The snake in this case is embodying the connection between kingship and the Egyptian pantheon. Luxurious as it is, this object probably decorated furniture in the royal household.

OPPOSITE

Upper part of a colossal statue of Ramses II
19th Dynasty, *c.* 1280 BC
Temple of Khnum, Elephantine, Egypt
Granite
H 158 cm , W 68 cm

RIGHT

Gold cobra wearing the red crown of Lower Egypt
After 600 BC
Egypt
Gold
H 17 cm, W 5.5 cm

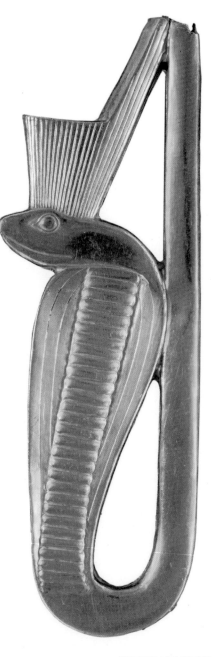

The double-headed serpent is both terrifying and exquisite. It is decorated with a mosaic that includes red and white shell for the mouth, but consists mostly of turquoise. This was the material most prized by the Aztecs in pre-Columbian Mexico. Their kings were adorned with turquoise when they performed the rituals, including human sacrifice, that were essential to their religious and political power. It is possible that this snake was a pectoral, or some other object connected with these ceremonial practices. Shimmering like the translucent plumage of the Quetzal bird, the serpent may represent Quetzalcoatl, the feathered snake-god with whom the Aztec monarchs identified. While the bird represented the heavens, the serpent was linked to the earth, and together they symbolized the cosmos over which Quetzalcoatl and his representative, the king, reigned. Above all, the skin-shedding, ever-youthful snake is a potent emblem of immortality.

A stone sculpture, probably taken from a temple façade, depicts the Aztec fire-serpent Xiuhcoatl at the moment of plunging to earth as a bolt of lightning. A creature with a snake's head and short, clawed limbs, its tail is formed by the Aztec year symbol: a triangle, like the solar-ray sign, with two entwined trapezes. The animal is both a terrifying physical reality and a complex piece of symbolism.

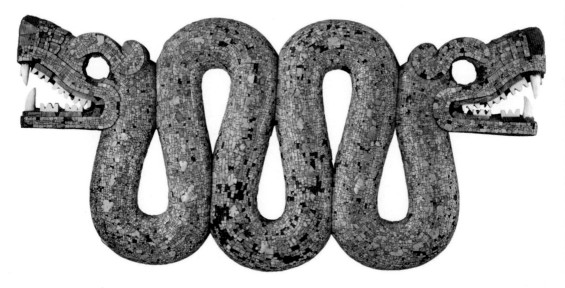

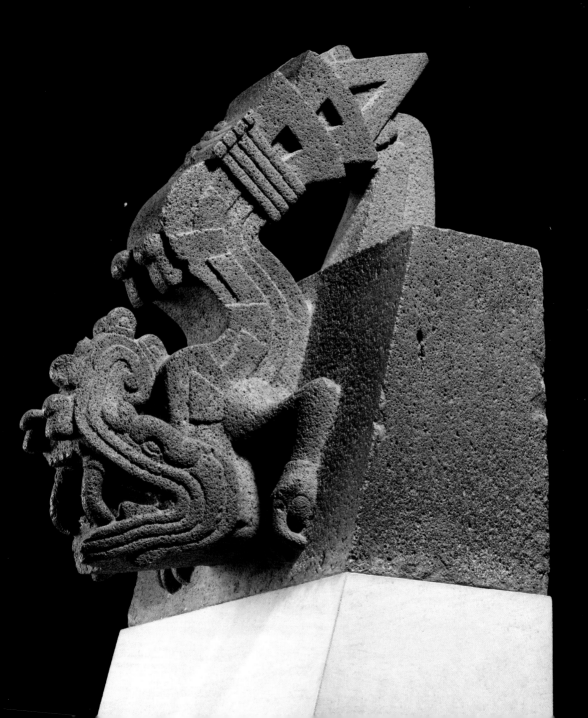

Rebirth and Immortality

The association of snakes with immortality derives partly from the shedding of their skin (page 140), but also from the motif of the ouroboros, Greek for 'tail devouring'. By representing a serpent as seemingly eating its own tail, the ancients created an image of a creature that, like eternity, had no beginning or end. In this Sasanian stamp seal, made from hematite, the central image is of a lion, star and crescent moon, enclosed by the ouroboros as a symbol of permanence. The gold snake bracelet, which was discovered at Pompeii, has a comparable circular form, though it is not actually devouring itself and its shape is most obviously connected to its function.

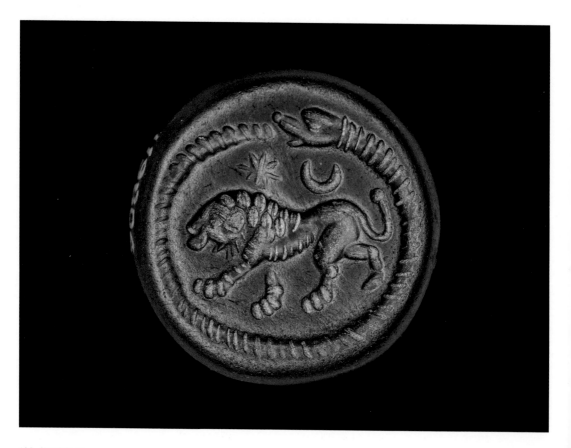

This monumental diorite sculpture represents the scarab, an ancient Egyptian symbol of rebirth and the rising sun. In one creation myth, the new-born sun had a scarab's head, and the hieroglyph of the scarab has a phonetic value that means 'to come into being'.

Monumental scarab beetle
c. 400–300 BC
Istanbul, Turkey
Diorite
H 90 cm, W 119 cm, L 153 cm

Loaded with such symbolism, scarabs were endowed with magical powers. This green jasper scarab, with its legs, inscribed with hairs, made out of the gold base, is a so-called 'heart scarab'. Carved with a simple human face, it is designed to protect a dead person's heart, the seat of personality and intelligence, when the soul is judged in the afterlife. Its magic is so powerful that the hieroglyphs at the base have been deliberately defaced, so that they will not themselves come to life and attack the deceased. As the dead person here was a King, Sobekemsaf, this object is thought to be the earliest surviving example of a royal heart scarab.

Heart scarab of Sobekemsaf II
17th Dynasty, c. 1590 BC
Thebes, Egypt
Gold and green jasper
L 3.8 cm, W 2.5 cm

This ancient Egyptian pendant represents a winged scarab beetle, pushing the sun-disc over the horizon, with the rising sun also appearing at the bottom, between papyrus flowers. As an image of dawn, it symbolizes rebirth, while also containing the hieroglyphs that make up one of the names of King Senwosret II. This high-status object was made with semi-precious stones inlaid in metal cells using the cloisonné technique.

The Egyptians' genius for combining personal adornment with profound religious symbolism can be seen in the hedgehog. A simple faience figure, with highly stylized spines, it may have been used to store kohl (black eye-paint), and in the back there is an opening into which a stick for applying the pigment could be inserted. Vanity did not exclude piety, and the hedgehog, like other creatures, seems to have embodied the quest for immortality. As an animal that can live in desert areas, and above all wakes up after hibernation, it was used in various contexts as a symbol of the renewal of life.

BELOW

Scarab pendant
12th Dynasty, reign of Senwosret II,
c. 1897–1878 BC
Egypt
Electrum, lapis lazuli, green feldspar and cornelian
H 1.8 cm, W 3.5 cm

OPPOSITE

Jar in the shape of a hedgehog
26th Dynasty, c. 700–500 BC
Egypt
Glazed composition
H 5.2 cm, W 3.7 cm, Diam 6.6 cm

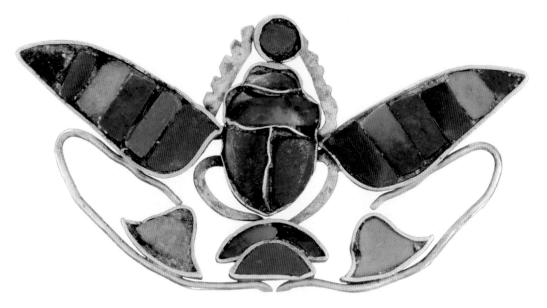

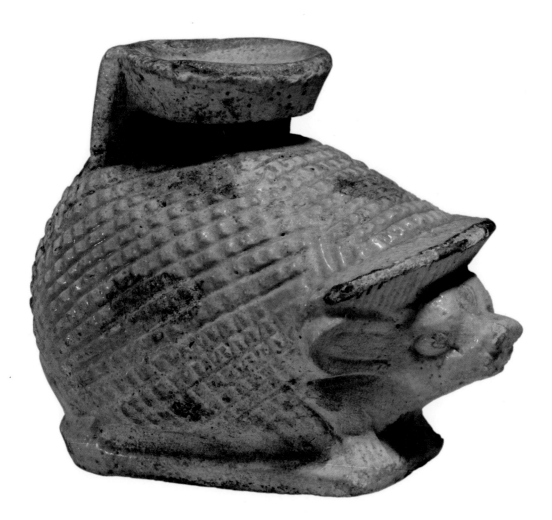

Tomb painting representing
the pool in Nebamun's garden
18th Dynasty, c. 1350 BC
Thebes, Egypt
Polychrome painted plaster
H 64 cm, W c. 73 cm

The tomb chapel of Nebamun, a temple official during the Egyptian New Kingdom (page 25), includes this fresco of a garden pond brimming with fish. As well as recreating the earthly pleasures that the deceased enjoyed while he was alive, the paintings are filled with funerary symbolism. In this picture, the most significant detail is the species of fish, the tilapia, which also appears here in the form of a rare glass bottle. The female tilapia is known for protecting her eggs, and even her recently hatched offspring, in her mouth. The re-emergence of the live fish was regarded by the ancient Egyptians as a symbol of rebirth.

Fish-shaped bottle
18th Dynasty, c. 1360–1340 BC
Amarna, Egypt
Glass
L 14.1 cm, W 7 cm

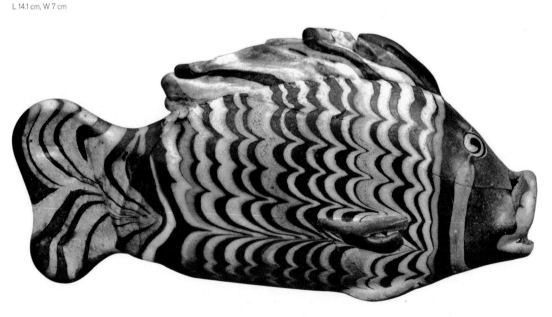

Gender and Sex

With its power and determination, the carp became
a symbol of manly perseverance in China and Japan.
The leaping carp in the Chinese woodblock print is
an image made in Suzhou for a young man striving
to pass civil service examinations. As Hiroshige's print
shows, kites in the form of carp were flown at the
mid-summer Boy's Festival in the Samurai district of
Surugadai in Japan. During the 19th century, with the
decline in political influence of the Japanese shogun
and warrior class, families that had once made armour
transferred their skills to producing articulated iron
sculptures of scaly animals such as reptiles and fish.

RIGHT

Suido Bridge and Surugadai
Utagawa Hiroshige (1797–1858)
1857
Japan
Colour woodblock
H 36 cm, W 24 cm

BELOW

Articulated figure of a carp
Myochin Muneyori
c. 1800–1850
Japan
Gold inlaid iron
L 44.1 cm

OPPOSITE

Carp and Swallow
Qing Dynasty, *c.* 1644–1753
Suzhou, China
Woodblock print on paper
H 59.7 cm, W 28.8 cm

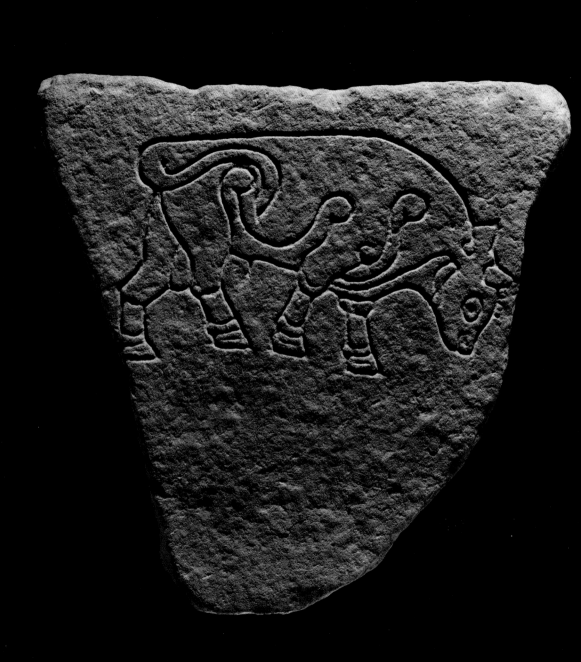

Horned creatures have been associated with masculinity in a range of cultures. The Pictish Burghead Bull from Scotland may originally have functioned as a memorial headstone, and the animal's strength and aggression suggests that it was connected with a warrior cult. In West African Benin society the ram also functioned as a male symbol, used here as the form for a bronze water container.

Cultivating tobacco and rearing cattle have been regarded as quintessentially male activities in various societies, including that of the Xhosa in South Africa. Here, a Xhosa artist has fashioned a snuff box to resemble a sturdy, long-horned ox. The use of snuff seems also to have had a ritual function, as a means of communicating with the realm of ancestors, and the artefact was made partly from the blood, hair and hide of cattle that may have been sacrificed. The object was not just a leisure accessory, but a powerful expression of identity, status and religious belief.

OPPOSITE
Burghead bull
c. AD 600–800
From Burghead, Morayshire,
Scotland
Stone
H 53 cm

RIGHT, TOP
Jug in the form of a ram, with lidded opening at the back of the head
c. 1500–1600
Benin City, Nigeria
Brass
H 34 cm, W 12.5 cm

RIGHT, BOTTOM
Ox snuff box
c. 1850–99
Recorded as Xhosa
Sinew, blood and hair
H 9.8 cm, W 7.5 cm

The boar appears to have been a symbol of masculine strength and courage in a range of cultures. The Anglo-Saxon Sutton Hoo ship burial included these remarkable gold shoulder clasps, from an otherwise lost piece of armour. The principal motif of two entwined boars, with lowered heads, at the rounded end of the clasps may have symbolized the dead warrior's fortitude, as well as demonstrating his status and wealth. The animals are made from garnets inlaid with the cloisonné technique in gold cells, with hip-joints of millefiori glass and blue glass tusks.

Gold shoulder-clasp inlaid with
garnet cloisonné and glass
c. AD 560/70–610
Found in Sutton Hoo Ship-burial
Mound I, Suffolk, England
Gold, glass and garnet
L 12.7 cm, W 5.4 cm (as a pair)

Seven centuries earlier, these copper-alloy figures of
a boar, from an Iron Age hoard in west London, were
probably originally attached to helmets or vessels.
They are vivid images of the animal, with flat snouts,
ears bent forward and arched, ridged backs.

Copper-alloy boar figures
c. 150–50 BC
Found in the Hounslow Hoard,
England
Copper alloy
L 4.8 cm (front), L 7.2 cm (rear)

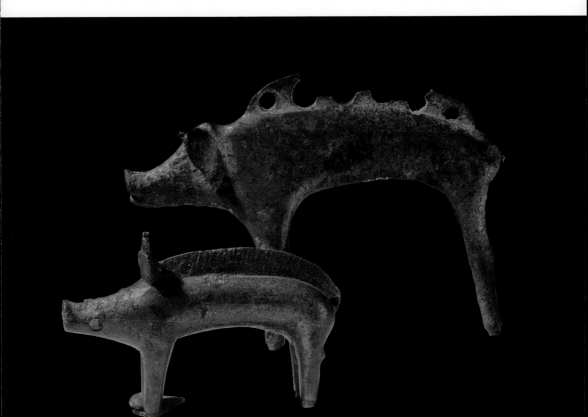

The unicorn is a mythical creature that was celebrated from antiquity to the early modern period for its supernatural powers, especially as an antidote to poison. Its single horn, which led to its confusion with creatures such as the narwhal, looks like a male symbol in itself, but the iconography of the animal was actually sophisticated in the extreme. By the Middle Ages, the creature had become a central character in allegories of courtly love. One example, an ivory casket made in 14th-century Paris, depicts the unicorn among various other scenes, including the love of Tristram and Isolde and the siege of the Castle of Love. In the detail depicted here, the unicorn is transfixed by a hunter as it embraces a seated lady beneath a tree.

RIGHT
Pin topped with the head of a unicorn
c. 1500–1600
Found in Bristol, England
Bone
L 9 cm

OPPOSITE (DETAIL BELOW)
Casket
c. 1325–50
Made in Paris, France
Ivory
L 21 cm, W 13 cm

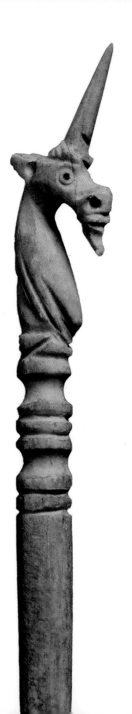

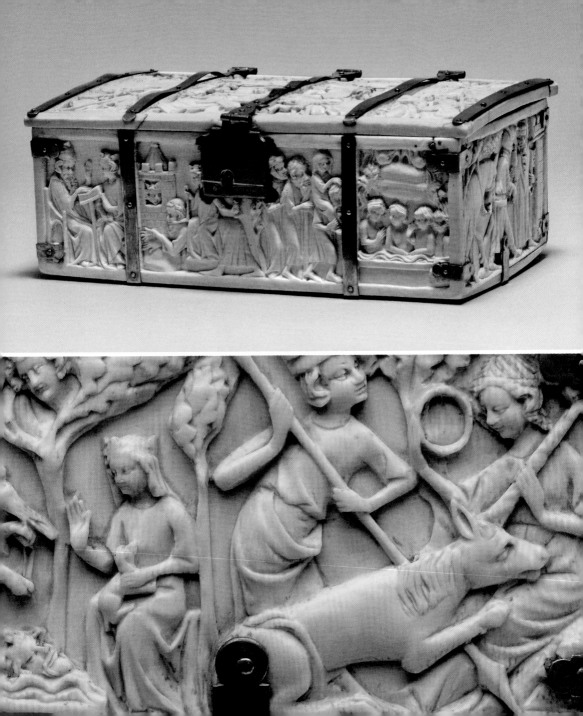

This tale was given a somewhat different emphasis in Master E.S.' engraving, where the beast is caressed not by an aristocratic lady but by a wild woman covered with fur. However, the courtly context was reaffirmed in the 16th century in a series of prints by Jean Duvet. The scenes illustrated below express the animal's transformation from a violent animal, an image of male aggression, into a paragon of gentleness and purity. Prior to being tamed, the unicorn attacks a group of huntsmen while a king and other riders flee to a city, but once it is united with the maiden it is tame enough to be tied to a trunk as it rests on her lap. With its emphasis on self-sacrifice, the story was generally interpreted as representing the Incarnation, the Virgin Mary's conception of Christ, his death and resurrection.

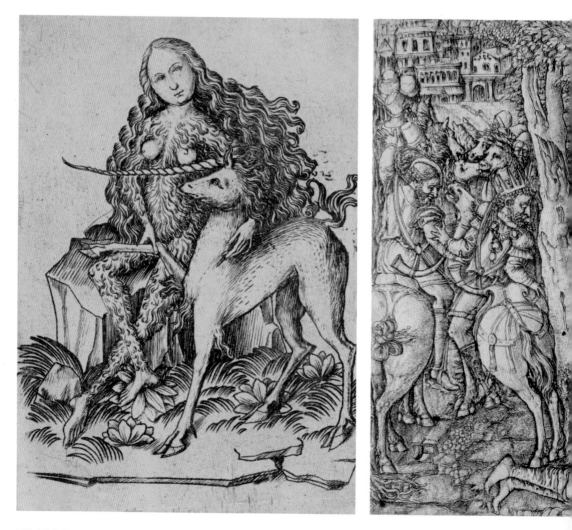

OPPOSITE

Wild woman embracing a unicorn
Master E.S. (1420–68)
1450–67
German
Engraving
H 9.8 cm, W 6.8 cm

BELOW

The Unicorn series
Jean Duvet (1485–1562)
1545–60
French
Engraving
H 23 cm, W 39 cm

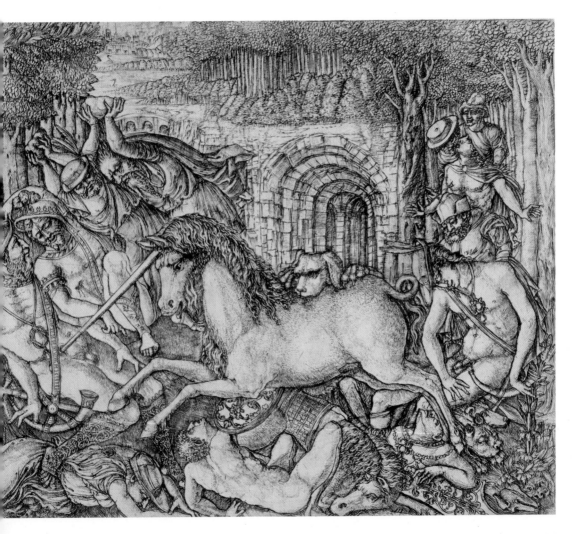

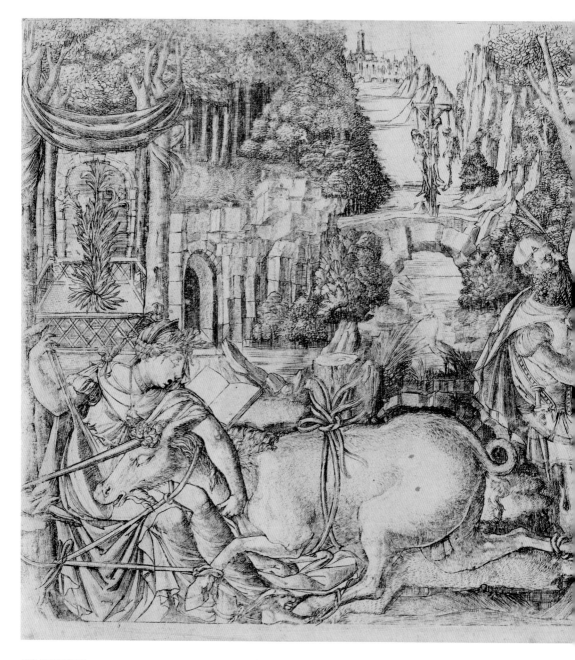

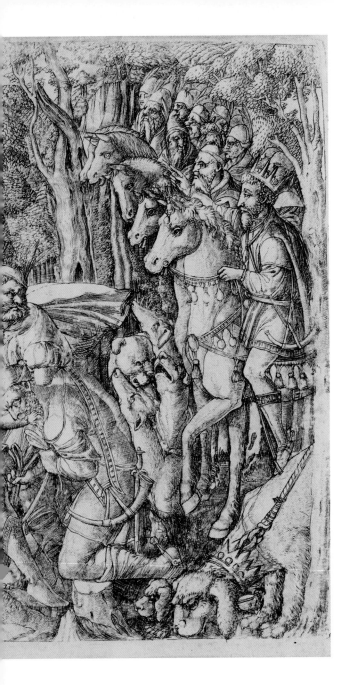

The Unicorn series
Jean Duvet (1485–1562)
1545–60
French
Engraving
H 23.7 cm, W 38.4 cm

— 5 —

HYBRIDS &
MYTHICAL
CREATURES

THE ARGENTINIAN AUTHOR JORGE LUIS BORGES wrote that
'We are as ignorant of the meaning of the dragon as we are of the meaning
of the universe, but there is something in the dragon's image that appeals to the
human imagination, and so we find the dragon in quite distinct places and times.'
These different cultures have in fact attached a great deal of significance to the
beast, but its qualities have ranged from the auspicious associations of the Chinese
dragon to the destructiveness of its Western equivalent.

Even the most threatening mythical characters can be useful. To Solomon
Islanders, the sea spirit on page 235, a hybrid figure combining human features
and the forms of fishes, was as dangerous as his startling appearance suggests.
This made him an ideal protector of the residence of a chief, to which he was
attached. In some ancient societies sphinxes, which also functioned as guardians,
had similarly ambivalent reputations. According to Greek myth, the sphinx at
Thebes destroyed all those she met after setting them a riddle that none could
solve, until the arrival of Oedipus. Such creatures embody primordial fears,
but also express the hope that we can deflect this terror away from ourselves
and towards our enemies.

Although belief in monsters was to dwindle in many cultures, these beasts
could still convey a strong allegorical meaning, like the Leviathan that Nelson
guides in William Blake's 'spiritual portrait' of the great admiral. When deprived
of this moral dimension, the creatures became merely diversions and luxurious
entertainments for the eye, such as the sea dragon fashioned from pearls on
page 243. Yet even here we have to admit the continuing appeal of this 'necessary
monster', as Borges termed the whole draconian family, which can excite our
imagination or sense of beauty long after we have rejected its existence.

To this day people seem to relish hybrids and mythical creatures, as is
demonstrated by the example opposite, made by a British artist of Trinidadian
heritage. Here the Moko Jumbie, a carnival character on stilts derived from
a traditional belief in ancestor spirits, has been transformed by the addition of
wings into an ambiguous figure, half guardian and half raptor.

Moko Jumbie
Zak Ové
2015
Greenwich, London, England
Steel, plastic, textile, copper,
wood and leather
H c. 4 m

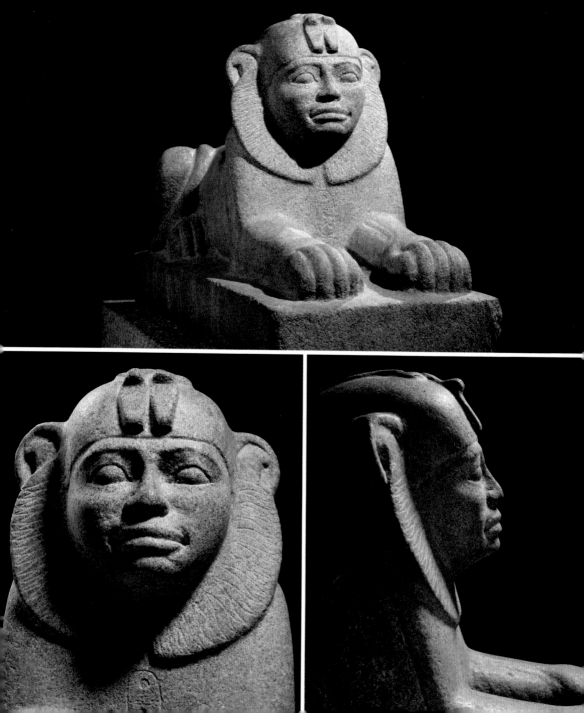

Guardians

Hybrid creatures were frequently endowed with the power to act as guardians. Their anthropomorphic features aligned them with the people that they were protecting, while their animal bodies indicated their superhuman qualities. The Nubian sphinx combines the body of a lion with a human head that may be a stylized portrait of Taharqa, one of the Kushite kings who ruled Egypt in the 8th and 7th centuries BC. The figure would have protected a shrine in Kawa, a temple site in Sudan.

The Assyrian *lamassu* from Nimrud is in fact assembled from three species. In addition to the bearded human face, the bull has acquired wings, the feathers, hair and hooves all represented with lapidary precision. As a figure that flanked a door, the creature has five feet, so that at least four would be visible from any angle. It is of an impressive scale, though this does not mean that such colossi awed everyone who came across them. The human guards who waited outside gates on occasion passed the time with board games, in certain cases cutting a grid into the base of the sculpture.

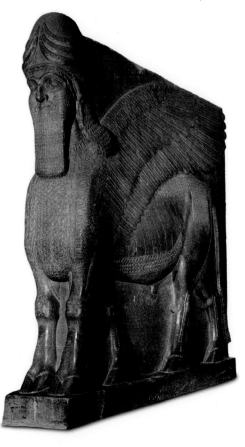

OPPOSITE

Sphinx of Taharqo
Kushite, *c.* 680 BC
Temple T at Kawa, Sudan
Granite
H 40.6 cm, L 73 cm

RIGHT

Statue of a winged human-headed bull
c. 865–860 BC
From the North West Palace, Nimrud, Iraq
Gypsum
H 309 cm, L 315 cm

This sphinx was carved in the reign of Amenemhat IV, a pharaoh of the Egyptian Middle Kingdom. Its history reflects the enduring popularity of this mythical creature. Many features, including the mane-like pattern on its breast, are characteristic of this period, and yet there is a clear disjunction in scale and style between the head and body. It was partly recut, probably in Ptolemaic times, over 1,500 years later, when the upper part of the mane was transformed into a cloth headdress and the sculpture was moved, perhaps from Heliopolis to Alexandria.

Sphinxes were highly versatile as well as popular guardians. In contrast to the recumbent stone figure, this sphinx or human-headed cat was made from wood, perhaps forming the leg of a piece of royal furniture. It is also possible that its function was to protect a woman in childbirth.

BELOW
Sphinx of Amenemhat IV
12th Dynasty, c. 1786–1777 BC
Beirut, Lebanon
Gneiss
H 38.1 cm, W 20.2 cm, L 58.5 cm

OPPOSITE
Part of the leg of a funerary
bed in the form of a sphinx
25th Dynasty, c. 800–600 BC
Sudan or Egypt
Wood
H 42.3 cm, W 7 cm

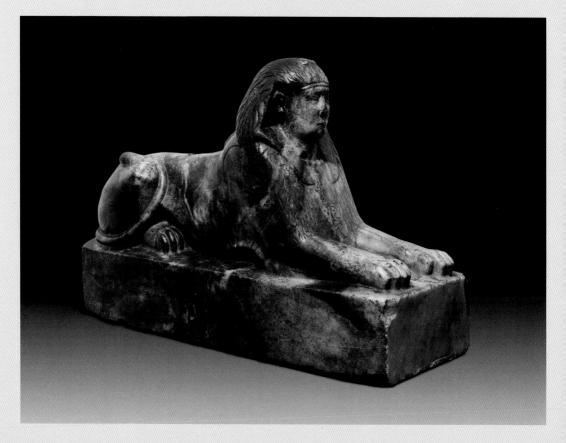

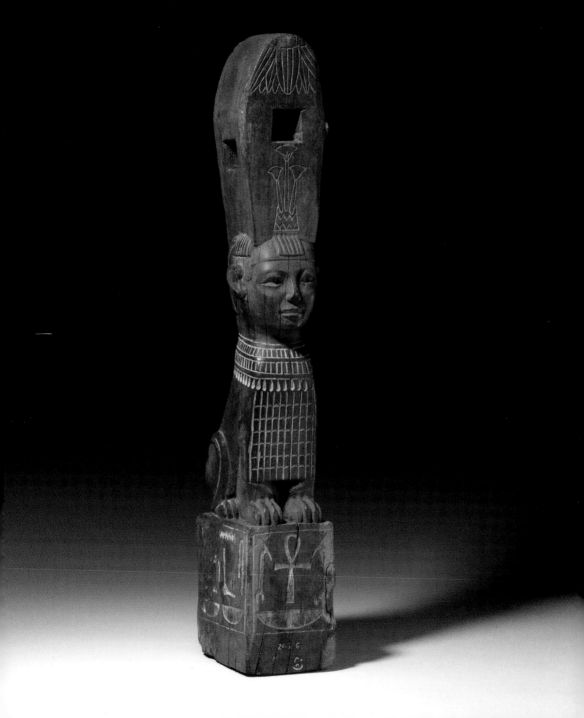

Each of the winged, falcon-headed sphinxes in this gold bowl wears a uraeus, a snake symbolizing kingship, as well as the double crown of Upper and Lower Egypt (pages 164–65). The sphinxes rest their front paws on a human head, while between each pair is a papyrus column supporting a winged scarab beetle holding a sun-disc with double-uraei. The Egyptian character of these motifs is remarkable, as the bowl was found in the Assyrian city of Nimrud and was probably made in Phoenicia. It testifies to Egypt's cultural influence, even in a period of political decline.

ABOVE, LEFT
Bowl depicting four pairs of
winged falcon-headed sphinxes
c. 900–700 BC
Excavated at North West Palace,
Nimrud, Iraq
Copper alloy
Diam 21.7 cm

ABOVE, RIGHT
Wooden seated figure of Taweret
18th Dynasty, reign of
Thutmose III or Horemheb,
c. 1300 BC
Thebes, Egypt
Wood and resin
H 32.5 cm, W 17 cm

ABOVE, LEFT

Wooden figure of an enthroned
ram-headed god
18th Dynasty, reign of
Thutmose III or Horemheb
c. 1300 BC
Thebes, Egypt
Wood and resin
H 57 cm, W 40.5 cm

ABOVE, RIGHT

Wooden figure of a
gazelle-headed guardian
18th Dynasty, reign of
Thutmose III or Horemheb,
c. 1300 BC
Thebes, Egypt
Wood and resin
H 37.3 cm, W 40 cm

These three wooden protective images are very
unusual examples from royal tombs in the Valley of
the Kings. Their human figures are combined with
animal heads – a hippopotamus, a ram and a gazelle
– and would originally have been covered with linen
and gesso and painted black. They resemble
characters that more often appear on the walls
of tombs carrying knives and snakes, which the
ram-headed creature might once have been holding.
Their purpose was probably to ward off evil during
embalming and other rituals associated with the
deceased's passage to the afterlife.

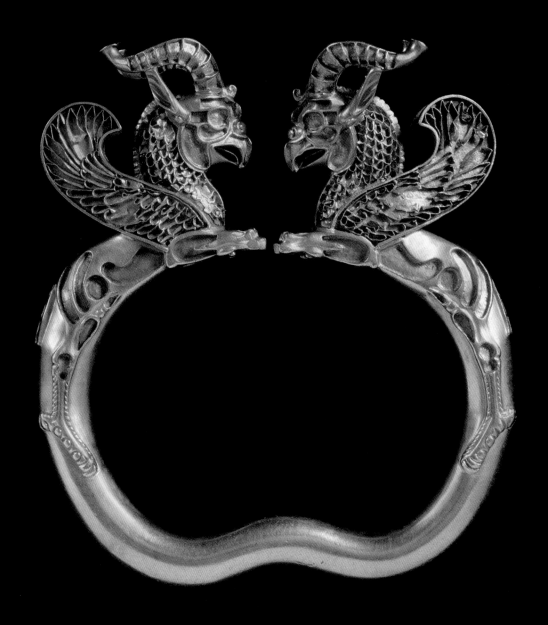

A griffin is a mythical beast with the body, tail and back legs of a lion and the head, wings and talons of an eagle. Like other hybrid creatures, it was given a protective function, to which the predators from which it is constructed were well suited. Its ferocity is particularly apparent in a gold coin minted in Panticapaeum, an ancient Greek city in the Crimea. The griffin adorns the reverse side, facing the viewer with a spear in its jaws and standing on an ear of corn.

For all their savagery, griffins are decorative creatures, especially with elaborations such as the curved horns in the gold armlet illustrated here. This artefact, which would have been inlaid with glass and semi-precious gems, is part of a treasure found on a branch of the Oxus river in Tajikistan in Central Asia. Its design suggests that it was made in Achaemenid Persia, where objects of this type were often given as tributes.

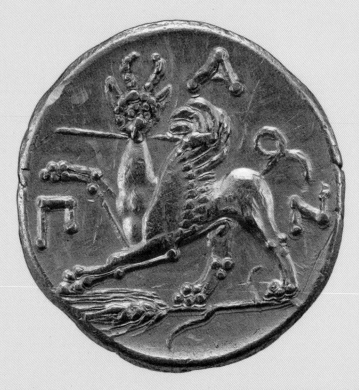

Hollow cast bronze griffin's head
c. 700–600 BC
Made in East Greece
Found on Rhodes (probably)
Bronze
H 32 cm

It was believed in the Middle Ages that a saint could acquire a griffin's claw as payment if he managed to cure the beast of a wound. This might explain the presence, documented in 1383, of griffins' claws and eggs at St Cuthbert's shrine in Durham Cathedral. In the 14th century, griffins were readily confused with other outlandish creatures, such as an ostrich, a rhinoceros or, less exotic, an ibex. It is the horn of this wild Alpine goat that is shown here, with a silver band around its mouth describing it as 'the claw of a griffin sacred to the blessed Cuthbert of Durham'. This fitting dates from the late 16th or early 17th century, but probably replaced an earlier inscription.

The ornamental bronze griffin head, in the Orientalizing style that dominated Greek art in the 7th century BC, once adorned the exterior of a cauldron. It has curious features, including long, pointed ears, combined with a sinuous, reptilian neck and sharp beak. Although originally attached to a cooking utensil, the image is highly artistic, with a strong attention to detail, extending to each scale and even the eyebrows.

Ibex horn with inscription
c. 1575–1625 (mount)
Found at the Shrine of
St Cuthbert, Durham, England
Ibex horn and silver
L 71.1 cm

The serpentine nagas and the mythical garuda bird are traditionally regarded as adversaries in Hinduism, Buddhism and Jainism. However, they both appear on this lavishly carved gendèr [gen-dare], a Javanese musical instrument with eleven bronze keys above a set of bamboo resonators. The garuda is a spectacular ornament to the front of the instrument, framed by a crowned naga on each side.

Because they are protective creatures in Buddhism, nagas are placed at entrances to temples and around images of the Buddha, and as a link between earth and the heavens, they form the balustrades of staircases. Here, a five-headed naga emerges from the mouth of a composite animal that also guards sacred places.

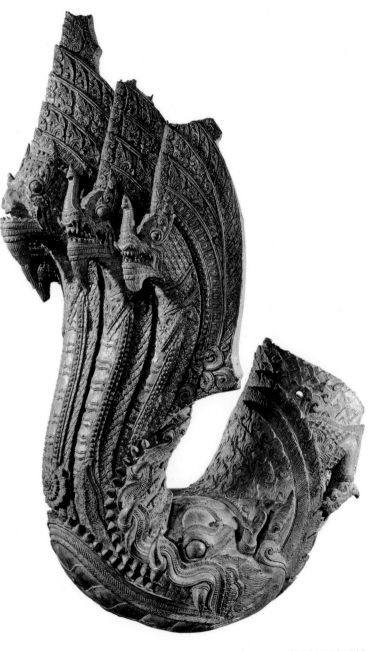

Instrument called a gendèr with
a garuda and two crowned nagas
Mid 1700s–early 1800s
Java, Indonesia
Wood, lacquer, gold, bronze
and bamboo
H 74 cm, W 134 cm

Gilded bronze balustrade
terminal depicting a five-headed
naga emerging from the mouth
of a makara
c. 1460–90
Wat Phra Sri Rattana Mahathat
Temple, Phitsanulok, Thailand
Gold and bronze
H 95.4 cm, W 65 cm

These savage figures were all intended to frighten away malevolent forces, though in very different contexts. When it was discovered in 1934, the carved wooden dragon from the River Schelde in Belgium was assumed to have come from a Viking vessel, but radiocarbon analysis has shown that it is in fact the figurehead of a boat from the late Roman period.

Other beasts are more ambivalent, including the fearsome mask-like tile from Gyeongju, the capital of the Silla kingdom in South Korea. It is usually identified as a dragon, but has also been described as a lion or a ghost. Glaring down from a temple roof, it would certainly have had a protective function, driving away malevolent spirits. An even stranger hybrid creature is the large ceramic Tang Dynasty tomb figure (see also page 73). With its draconian features, spiky wings and bizarre outgrowths, it is a ferocious guardian spirit, though its cloven hooves associate it with the qilin, a Chinese mythical bringer of good luck (pages 212–13).

Chu tomb guardian figure
with real antlers
Eastern Zhou Dynasty,
c. 400–200 BC
Changsha, Hunan, China
Wood and antler
H 43.7 cm

BELOW
Red deer antler headdress
c. 8000 BC
From Star Carr, Vale of Pickering,
England
Antler
H 15 cm

Shamanism, in which specialist individuals communicate with spirits, often involves the wearing of animal parts. This ancient wooden figure, with its lacquered antlers, probably represents such a practice, and would have guarded a tomb in the southern Chinese state of Chu. The Stone Age headdress, made from the trimmed skull and antlers of a red deer, is probably also an example of this type of costume, although it has been suggested that it may have been worn as a disguise during hunts. It would have been worn with a leather thong that was run through the holes bored into the bone and was discovered with twenty other examples at the Mesolithic site of Star Carr in Yorkshire.

Bringers of Good Luck

East Asian societies such as China and Korea regarded dragons as bringers of good fortune. The Chinese associated them with imperial authority and frequently represented them in luxury objects, such as this unusual flat Yun Dynasty plate, where the sinuous beast extends its claws towards a pearl. Two dragons flying between clouds adorn the Korean porcelain jar from the late Joseon period, when such motifs became popular among commoners as well as at court. Here the figures combine grotesque features, such as bulging eyes and slavering jaws, with a subtle use of cobalt blue pigment.

With their auspicious qualities, both the dragon and the phoenix were appropriate subjects for this bronze charm from Qing Dynasty China. Although it looks like a coin, it was probably made to bring harmony and good fortune to a marriage. The creatures' associations with masculinity and femininity, and their union here, made them especially fit for this purpose, as did the inscription: 'irreproachable virtue'.

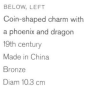

BELOW, LEFT
Coin-shaped charm with
a phoenix and dragon
19th century
Made in China
Bronze
Diam 10.3 cm

BELOW, RIGHT
Dish with a dragon chasing a
flaming pearl on a blue glaze
Yun Dynasty, c. 1330–68
Jingdezhen, China
Porcelain
H 1.5 cm, Diam 15.2 cm

OPPOSITE
Jar decorated with dragons
and clouds
c. 1800–1900
Korea
Porcelain
H 50.2 cm, W 29.1 cm (max)

This articulated iron figure of a dragon, probably once displayed in an alcove in a reception room, is a captivating image of this mythical creature and bringer of good luck. Many of its individual parts, including its claws, are movable, and it exemplifies skills developed by Japanese armourers, which were later transferred to other art forms. The need to do this intensified after the fall of the Tokugawa shogunate in 1868, with the decline of the militaristic culture that had dominated Japanese society and its economy up to this point.

Ganesha, the Hindu elephant god, had a Japanese equivalent known as Kangiten, who was associated with financial success. Kangiten is normally presented as an elephant-headed couple locked in an embrace and was often concealed in temples inside a cylinder, as if to spare the worshipper's blushes. This image includes an end-on view of one of the writhing trunks.

Articulated figure of a dragon
Myochin Kiyoharu
18th–19th century
Japan
Gilded iron
H 11.9 cm, W 9.2 cm, L 33.6 cm

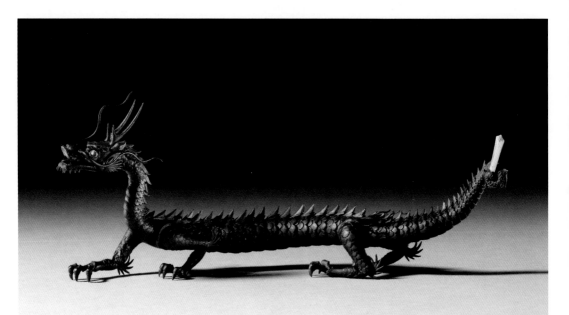

Figure of the deity Kangiten
in the form of two elephants
embracing
19th century
Japan
Bronze
H 4.25 cm

In China, a qilin was a bringer of good luck. It varied hugely in anatomy, ranging from a type of deer or unicorn to a dragon-like beast, sometimes with leonine features. It also appeared in different contexts and functions. The examples here range from lamp stands to the painted decoration of a porcelain desk stand, above a box for ink-sticks and brushes.

The hakutaku, a Japanese mythical creature with an ox's body, a man's head, three eyes on each flank and horns on its back, was believed to offer protection against bad luck and danger, and images of them were carried on journeys and put by the pillow at night. This netsuke, which also has a luxurious tail and an additional eye, may have performed such a role.

OPPOSITE
Desk stand in the form
of a screen with relief
Ming Dynasty, c. 1540–1600
Jingdezhen, China
Porcelain and gold
H 27 cm, W 12.7 cm

ABOVE
Bronze lamp stands
c. 1735–95
Beijing or Chengde, China
Wood and lacquer
H 56 cm

RIGHT
Hakutaku netsuke
Masanao of Kyoto
Late 1700s
Kyoto, Japan
Ivory
H 3.6 cm, W 4 cm

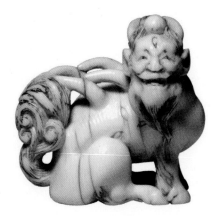

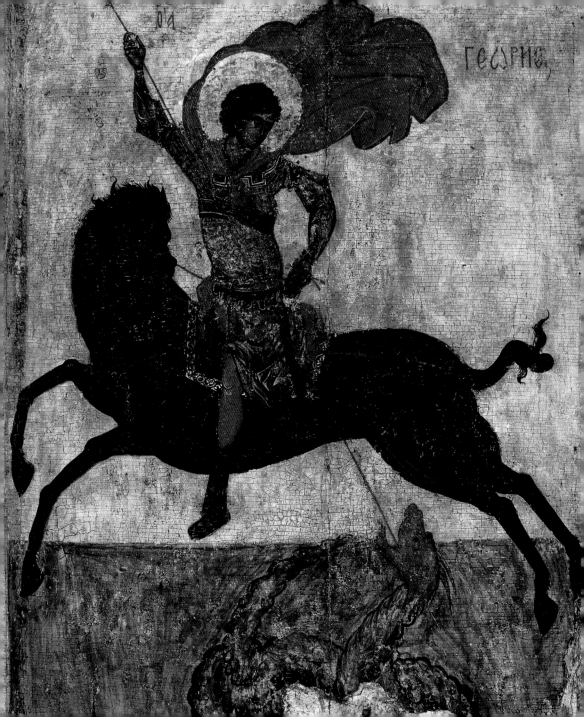

Agents of Death

In Europe, dragons are invariably creatures of darkness and death, often locked in combat with Christian heroes such as St George. The Russian icon, made in the area of Novgorod around 1400, has certain distinctive features such as its black, rather than light-coloured, horse and the absence of the princess whom the saint was rescuing. However, with its powerful design and contrasts of hue it is a classic example of the theme.

The archetypal conflict between the dragon and a virtuous woman is emphasized in the medieval French sculpture of St Margaret of Antioch. According to the 'Golden Legend', the medieval account of saints' lives, Margaret was tortured by a senior Roman official on account of her Christianity. Among the many miracles that occurred, she was devoured by Satan in the form of a dragon but emerged alive when the cross that she was holding irritated the beast's insides. Even though the 'Golden Legend' describes this story as apocryphal, it was frequently represented in this period.

OPPOSITE
Icon of St George
('The Black George')
c. 1400–50
From the village of Il'inski,
northwestern Russia
Wood, gold and gesso
H 77.4 cm

RIGHT
Statuette of St Margaret
of Antioch
c. 1325–50
Made in Paris, France
Ivory, with paint and gilding
H 14.5 cm

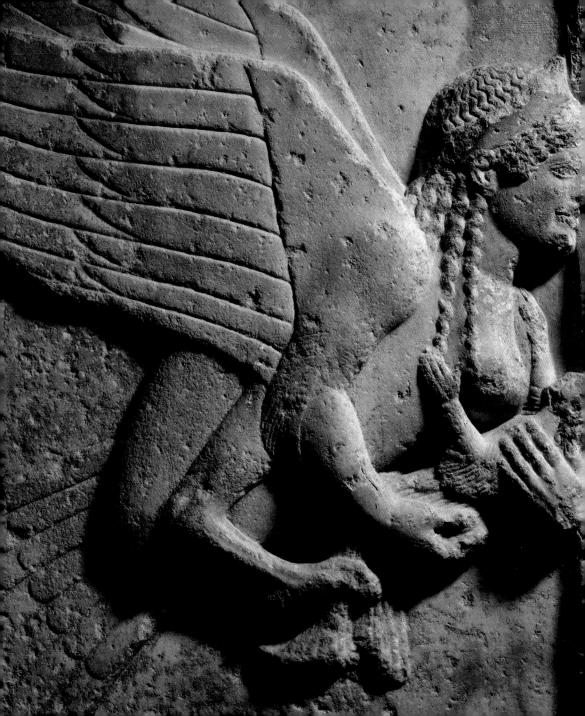

Marble relief from the Harpy
Tomb
Greek, c. 480–470 BC
Made in Lycia, Greece
Found in Xanthus, Turkey
Marble
L 61 cm

The Siren Vase
Greek, c. 480–470 BC
Made in Attica, Greece
Said to be from Vulci, Italy
Pottery
H 34 cm

The bird-like creatures with women's features in this sculpture have been described as harpies, agents of the wind who enforced divine justice in Greek mythology. They are in fact more likely to be sirens, best known for luring sailors to their death, as in Homer's account of the travels of the hero Odysseus, who resisted the Sirens' blandishments by having himself tied to the mast of his ship. The episode is memorably depicted in the Attic red-figure vase by the so-called Siren Painter.

Rather than leading mariners astray, the sirens in the relief are bearing souls to the Underworld, as they decorated a tomb in Xanthos, the most important city of ancient Lycia, now part of Turkey. Their marine associations would also have made them suitable for this function as the deceased, the ruler Kybernis, was a naval commander. Significantly, their hybrid character identifies them as supernatural, ministers of the gods though not divine themselves.

The ancient Etruscans of central Italy created images derived from Greek art and mythology that were nonetheless highly distinctive. In this black-figured amphora, the gesticulating Sirens stride around the vessel, hardly remaining within the space allocated to them, while more conventional birds adorn the vase's shoulder.

Perhaps out of necessity, a classical Greek bronze presents one of these creatures in a static, avian pose, its claws positioned demurely together in order to support the rest of the sculpture. The air of elegance is heightened by the Siren's adornments, a bead necklace and a headband.

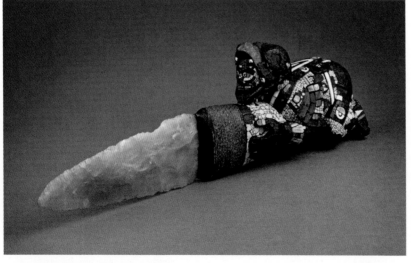

Eagles were associated in Aztec Mexico with the solar deity Tonatiuh. This stone relief of the bird, with its unusual backward glance, was associated with the sun-god's cult, which involved the capture of sacrificial victims by warriors dressed as eagles. One of these men, made from turquoise, malachite and shell, constitutes the handle of the knife. Crouching and grasping the haft, the figure vividly represents the rituals for which the weapon was probably intended.

Human sacrifice, and more specifically decapitation, is also the subject of this double-spouted jar from the Nazca culture in Peru. Here, a head is held in the mouth of a human-faced bird, whose diadem indicates that he was revered by the Nazca people. Their descendants still regard birds such as the condor as manifestations of their gods.

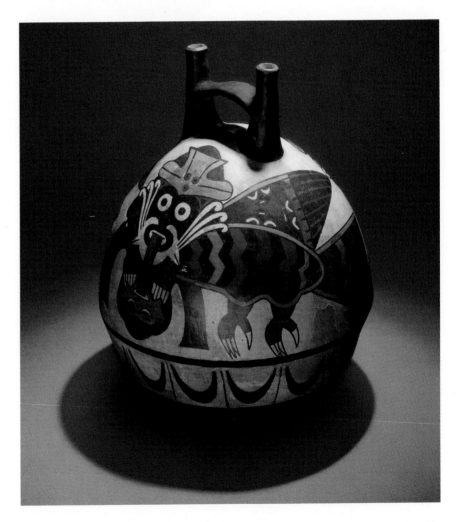

The jackal-headed Anubis was a god of the ancient Egyptian afterlife who was particularly concerned with funeral rites. He is shown here mummifying a corpse in a detail from the Book of Breathing, a collection of spells intended to help the deceased in the afterlife. He is often represented with a semi-human form, but sometimes appears with the body of a jackal, as in the pectoral, an ornament worn over the chest, which also has a winged 'wedjat' or sacred eye in the corner. Its colours, yellow and blue, are associated with resurrection, emphasizing Anubis's role in ensuring the immortality of the deceased.

Sokar was a falcon-headed god with a complex significance, including a role in funerary rituals. Here, the mummified body of a hawk was placed inside a painted coffin that resembles Sokar, while the mummy's bandages bear the wax face of Osiris, the Underworld divinity with whom Sokar was associated. The presence of the bird inside this image of a god shows the close relationship that the Egyptians perceived between nature and the divine.

OPPOSITE
Painted wooden coffin
containing the mummy of a hawk
Late Period, 664–305 BC
Egypt
Wood, wax and linen
H 58.4 cm

RIGHT, TOP
Embalming vignette from the
Book of Breathing of Kerasher
Reign of Augustus, 27 BC–AD 14
Thebes, Egypt
Papyrus
H 27.9 cm, W 86 cm

RIGHT, BOTTOM
Pectoral in the form of temple
gateway with the god Anubis as
a jackal and a winged sacred eye
19th Dynasty, c. 1250 BC
Egypt
Glazed composition
H 11 cm, W 10.6 cm

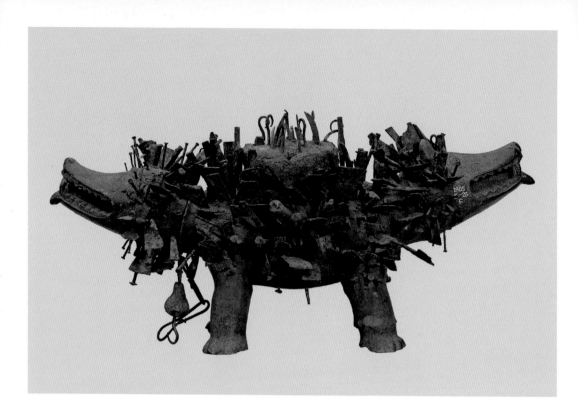

Kozo, the double-headed dog from Kongo, had a
magical function. As animals who moved between
the village and its surroundings, dogs were seen as
intermediaries with the dead, who were buried in
cemeteries separate from settlements. Dogs were
therefore useful for divination, especially if, as here,
they had four eyes. A ritual specialist would drive a
blade into the animal's body, which has fur made of
nails and a pack of medicines on its back. By uttering
the correct invocations, the soothsayer could discover
information such as the location of wrongdoers.

Figure of Kozo, the double-
headed dog
c. 1900
Kongo, Democratic Republic
of Congo
Iron, wood and resin
H 28 cm, W 25 cm, Diam 64 cm

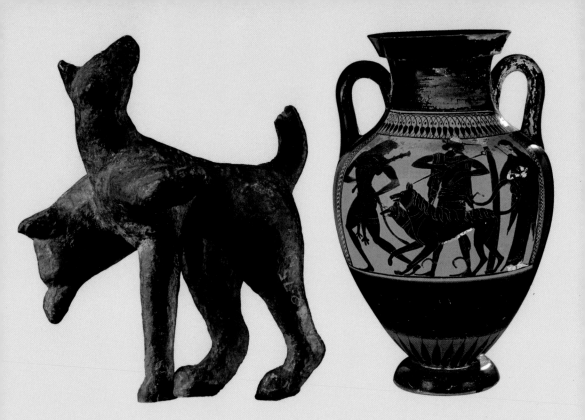

Figure of Cerberus
Date unknown
Place of production unknown
Bronze
H 5.8 cm

Black-figured amphora depicting Heracles and Cerberus
Greek, c. 490 BC
Made in Attica
Found on Aegina, Greece
Pottery
H 43.8 cm

Another multi-headed hound, Cerberus guarded the gates of Hades, the ancient Greek Underworld, in order to prevent anyone leaving. His images range from a snake-fringed body with three heads to the less extreme versions illustrated here. In the tiny bronze sculpture, he looks almost like a regular dog, in the process of licking his forepaw with one of his three heads. The black-figured amphora presents his most famous appearance in legend, when Heracles, as one of his twelve labours, fetched him from Hades. The hero, wearing a lion skin, is shown dragging the two-headed beast by a chain, accompanied by the gods Hermes and Persephone.

The Egyptian lioness-headed Sekhmet was a dangerous, malevolent goddess, especially when she took the form of the Eye of Re, the sun-god, whose disc appears above her head. In the Great Harris Papyrus, where Sekhmet and her fellow gods of Memphis are venerated by King Ramses III, the brilliant yellow circle is framed by a cobra.

As goddess of pestilence and the burning desert heat, Sekhmet had to be propitiated. For this reason, many of her sculptures were made for Amenhotep III's mortuary temple at Thebes, from which they were later taken to the temple of Mut, another lion-headed goddess, at Karnak.

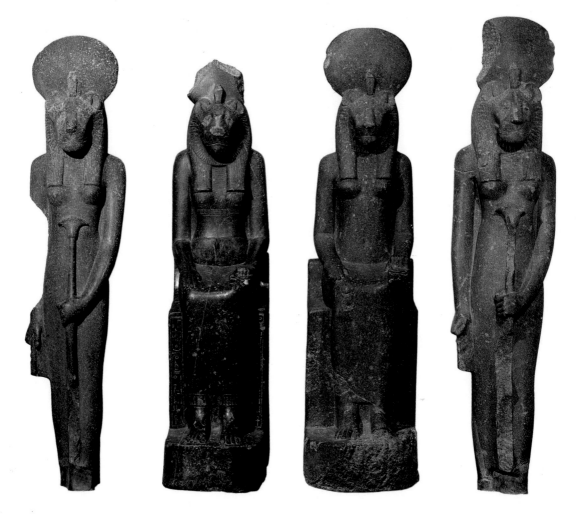

The minotaur was the monstrous progeny of Queen Pasiphaë of Crete and a white bull, which had been sent to the Queen's husband Minos by the god Poseidon. This unholy union was Poseidon's punishment for Minos's failure to sacrifice the bull, and produced a beast that is usually described as a bull's head on a man's body. This Late Minoan seal from Crete offers an interesting variant, the foreparts of a bull and a goat joined to human legs.

According to legend, the minotaur was housed in a labyrinth and fed on a tribute of Athenian youths and maidens, until it was killed by the hero Theseus, with the help of Minos's daughter Ariadne. It is the moment of slaughter that is represented in this Attic black-figure amphora, with the minotaur falling to one knee.

BELOW, LEFT
Lentoid seal engraved with a design of a minotaur
c. 1450–1350 BC
Made on Crete, Greece
Porphyry
Diam 1.7 cm

OPPOSITE
Black-figured amphora depicting Theseus slaying the Minotaur
Greek, c. 540 BC
Made in Greece
Pottery
H 37.5 cm

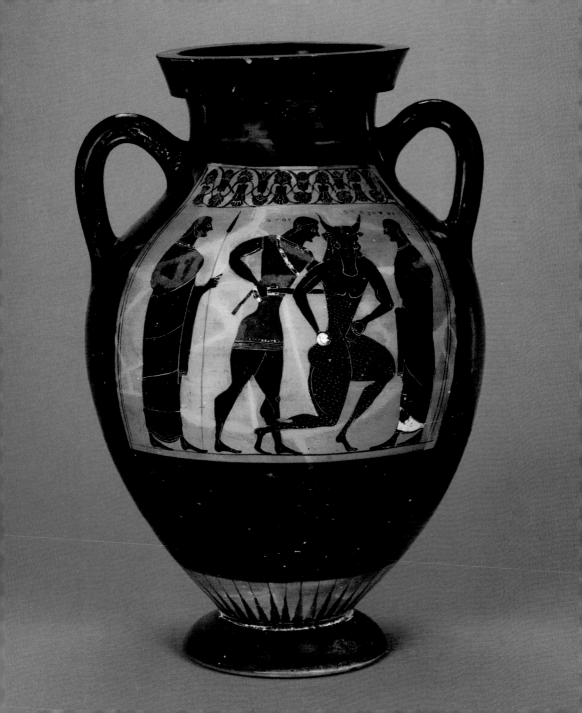

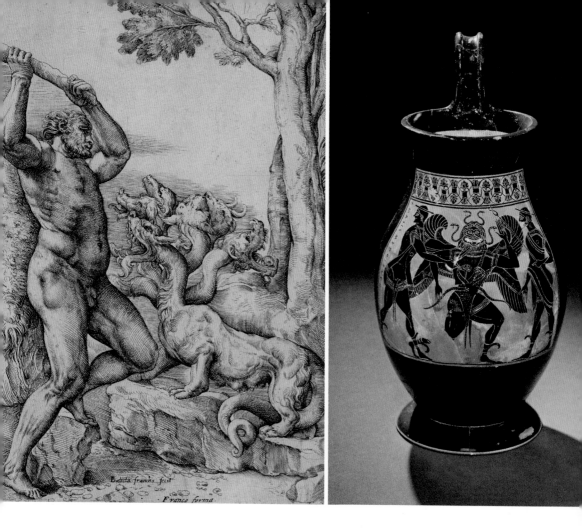

Snakes have generally not been favoured by Western culture. The horror that they arouse is compounded in mythical beasts such as the many-headed hydra of Lerna, which Hercules fought as the second of his twelve labours. Here, the Renaissance artist Battista Franco has created a magnificent composition of the hero raising his club against the monster. The classical legend tells us that the hydra's heads had a nasty habit of multiplying when they were struck off. Only by burning the stumps could the creature be defeated.

ABOVE, LEFT
Hercules raising a club to kill the
Hydra of Lerna
Battista Franco (c. 1510–61)
1530–61
Italian
Etching
H 31 cm, W 21.2 cm

ABOVE, RIGHT
Black-figured *olpe* (jug)
depicting Perseus slaying
Medusa
c. 550–530 BC
Made in Attica, Greece
Pottery
H 25.5 cm

Antefinial gorgon

c. 500 BC

Found in Capua, Italy

Terracotta

H 29 cm

The serpent-haired Medusa, one of the three Gorgon sisters, was so ugly that anyone who looked directly on her was turned to stone. Fortunately, we are viewing an architectural fragment, a terracotta *antefix*, intended to cover the ends of tiles, from the roof of a building in Capua in southern Italy. The medusa's snakes, tusks and lolling tongue, as well as her wings, also appear in the black-figure jug. Here she is shown at the moment in which the hero Perseus, looking the other way, plunges a sword into her neck.

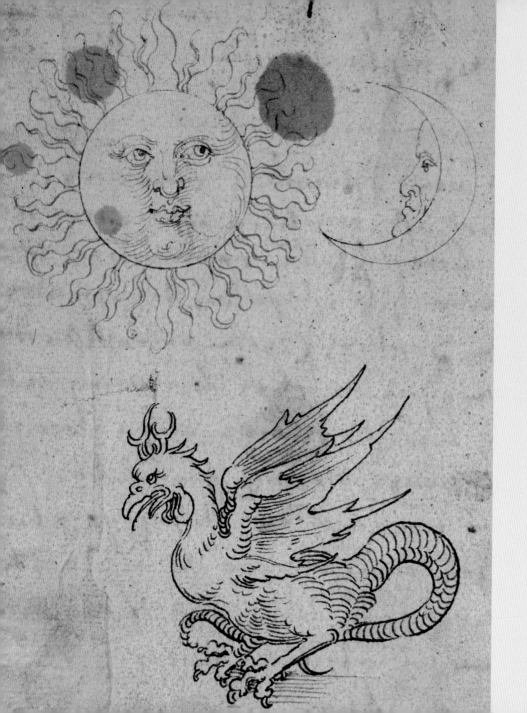

A basilisk was a mythical reptile, with wings and other bird-like features, which had the power to cause death by a single glance. As 'king of the serpents' it was represented with a crown-shaped crest. In Master DS's woodcut the basilisk, the heraldic animal of Basel in Switzerland, supports the city's coat of arms, strung from his neck. From 1511 the image functioned as a printer's mark for the Basel publishers Amerbach, Petri and Froben, and is a fine example of the 16th-century flair for heraldry and other symbols.

Dürer's dynamic drawing of a basilisk, accompanied by the moon and the sun, illustrated a manuscript that his friend Willibald Pirckheimer wrote around 1512/13. The text was a Latin translation of the 'Hieroglyphica' composed by Horapollo Niliacus in the 4th or 5th centuries AD, which attempted to explain Egyptian hieroglyphs in terms of arcane religious symbolism. Although this interpretation is incorrect, Pirckheimer's version was highly influential, stimulating the Renaissance interest in elaborate devices and emblems.

OPPOSITE

The sun, the moon and a basilisk
Albrecht Dürer (1471–1528)
1507–19
German
Pen, black and brown ink
H 25 cm, W 19.2 cm

RIGHT

A basilisk supporting the arms
of the City of Basel
By Monogrammist DS
1511
German
Woodcut and letterpress
H 21.1 cm, W 14.2 cm

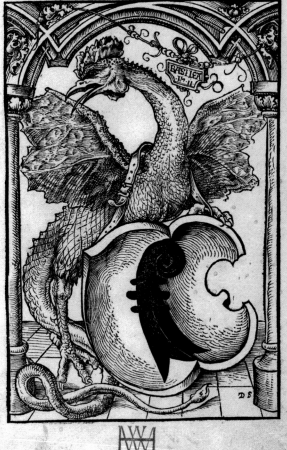

Secūda pars summe reuerēdissimi in christo patris ac dñi: dñi Antonini archiepi florentini.

BASILEA 1511

DS

Sea Spirits and Monsters

Fishermen and voyagers of the southeast Solomon Islands were always wary of the dangerous spirits of the open seas. This image of such a spirit guarded a chief's house on the island of Makira. It has fish for its head, hands and feet, including sharp-nosed garfish, the spears of the sea spirits, which could injure men when they leapt from the water.

In the southeast Solomon Islands, dead ancestors might be incarnated as sharks, which would protect their descendants at sea. In one well-known story, a living man became a shark and carvings showed him changing shape. This figure of a half-man half-shark is the handle of a bone spatula for taking lime when chewing betelnut.

RIGHT
Carved lime spatula with the
handle in the form of a shark-man
Pre-1910
Malaita, Soloman Islands
Bone
L 42.4 cm

OPPOSITE
Sea-spirit figure with fish
attributes and a collar of white
feathers
Pre-1893
Makira, Solomon Islands
Wood and feather
H 72 cm

This Japanese netsuke may look like a seahorse, but it is in fact an imaginary creature. It was hung from a kimono sash, with its bowed head hooked over the cloth and the cord attached through the space at the end of the tail. This is an animal whose form is determined by its function.

Mermaids and mermen have a broader appeal. Belief in their existence was widespread and long-lasting: their origin goes back to antiquity, but as late as 1822 a mermaid from Japan was exhibited in London. The example illustrated here was supposed to have been caught in 18th-century Japan, and was given to Prince Arthur of Connaught two hundred years later. Naturally neither of these specimens was entirely authentic, consisting of the dried parts of a primate and a fish's tail.

BELOW
Figure of a 'mermaid' composed
of the upper part of a monkey's
body and a fish tail
c. 1700–1800
Japan
L. 38 cm

OPPOSITE
Seahorse netsuke
Mid 1800s
Japan
Bone, coral and dark horn
H 7.5 cm

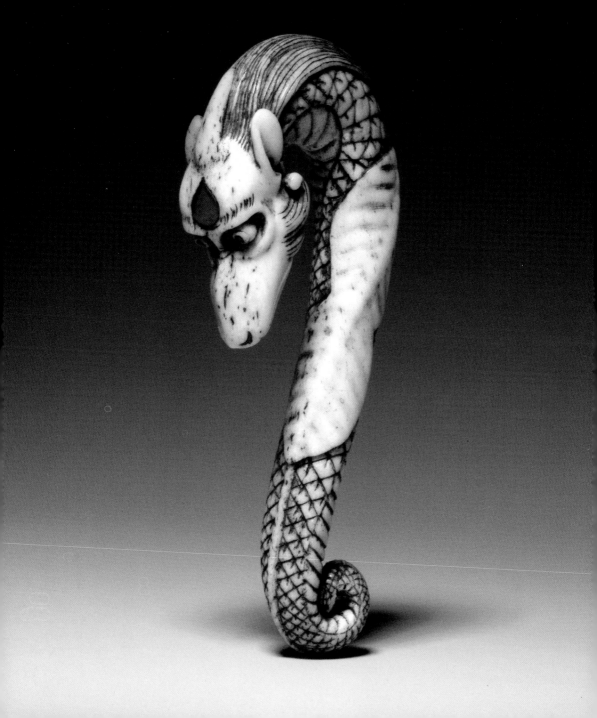

ABOVE

Articulated wooden headdress
in the form of a mermaid
1950s
Guerrero, Mexico
Wood and fibre
L *c.* 114 cm

LEFT

Struck bronze medal with
a mermaid (reverse)
Modelled by Paul-Marcel
Dammann (1885–1939)
1929
Made in France
Bronze
Diam 6.8 cm

Ewer in the shape of a mythical
being
Liao Dynasty, AD 907–1125
Lindong kilns, Inner Mongolia
Stoneware
H 13.4 cm, W 18.2 cm

Mermaids are versatile. They are fitting subjects
for role-play and popular entertainment, as in the
dance mask from Mexico with its bright tail and
moving parts. The bronze medal, dedicated to the
French composer Albert Roussel, offers us the classic
Western image of a mermaid who is both sensual
and remote.

The mermaid-like creature from Liao Dynasty China
has a body half-covered with fish scales, an upturned
fish tail and feathery wings. Mermaids are not usually
part of Chinese iconography, and this winged figure
may be more closely related to the angel-like flying
Buddhist apsaras that appear in Tang and Liao paintings
with similarly benevolent faces and clasped hands.

At first glance, Scylla looks like a mermaid, but closer inspection of both this terracotta votive plaque and the silver coin reveals not only the coiled body of a fish but also two dogs' heads projecting in front. This is the monster that, according to Greek legend, lived on one side of a strait facing another beast called Charybdis. Sailors trying to avoid one creature were likely to stray towards the other – hence the phrase 'between Scylla and Charybdis' describing a unique type of dilemma.

Relief plaque with Scylla
Greek, c. 450 BC
Made on the Cyclades
Found on Aegina, Greece
Terracotta
H 12.5 cm

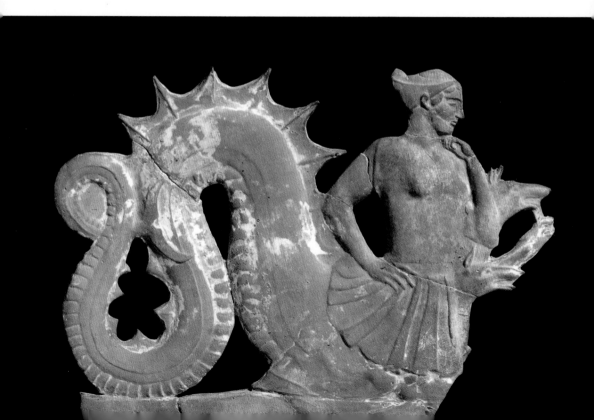

Black-figured hydria depicting
the contest of Heracles and Triton
Greek, *c.* 530–520 BC
Made in Attica
Found in Vulci, Greece
Pottery
H 42.5 cm

Silver coin with a depiction
of Scylla (reverse)
c. 420–410 BC
Minted in Agrigentum, Italy
Diam 2.5 cm

Classical antiquity also created Triton, a fish-tailed son of the sea god Poseidon, who had a human form only as far down as his chest. This Attic black-figure vase shows the struggle between this divinity and the hero Heracles, in his characteristic lion's skin with his legs around the hybrid's body. Triton himself has long hair, a pointed beard and other man-like features, until the scales take over.

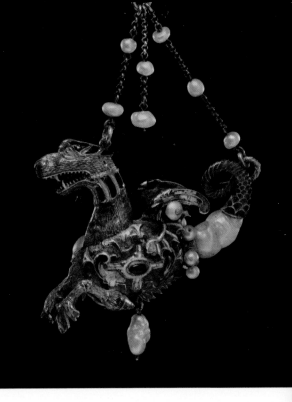

The nautilus shell from the South China Sea would have been an exotic object in mid-16th-century Europe, even without its engraved decoration of dragons on a scaly background. Rising to the challenge, Renaissance craftsmen transformed the shell into a decorative cup enclosed by the silver-gilt jaws of a sea monster. On the beast's head the infant Hercules grasps a snake, and the whole structure rests on an eagle's claw, probably cast from an actual specimen.

Even more extravagant are the sea-dragon and hippocamp, a creature that combines a fish's anatomy with the upper section of a horse, here ridden by a woman holding a trident. Dripping with pearls, these pendants also blaze with gold, enamels of different hues and, in the case of the marine horse, emeralds.

LEFT

Engraved glass ewer

Cristalleries de Baccarat

c. 1878

Lorraine, France

Glass

H 31.9 cm

OPPOSITE

Grandibus exigui sunt pisces
piscibus esca (The big fish eat the
little fish)

Pieter van der Heyden
(c. 1530–after 1584) after Pieter
Brugel the Elder (1526/30–69)

1557

Netherlandish

Engraving

H 22.7 cm, W 29.6 cm

This ewer, made by the celebrated workshop Cristalleries de Baccarat, explores the fantastical nature of a sea monster by elaborating its anatomy in glass. The mouth is formed by the vessel's spout; scales are represented by wheel-engraved decoration on its neck and shoulders; and its tails entwine luxuriously near the base. Inspired by early 17th-century rock crystal, this is a prestigious piece that was originally displayed in 1878 at the Exposition Universelle in Paris.

While the glasswork is a luxury artefact, Pieter van der Heyden's engraving, based on Bruegel the Elder's composition, launches a direct attack on greed. An all-devouring monster releases smaller fish, which in turn are gorging themselves, with hybrid creatures, such as the fish-man on the left, continuing the satire. In the boat a man suitably instructs his child, and a text below declares: 'the rich oppress you with their power'. Fantasy has been put to the service of political allegory.

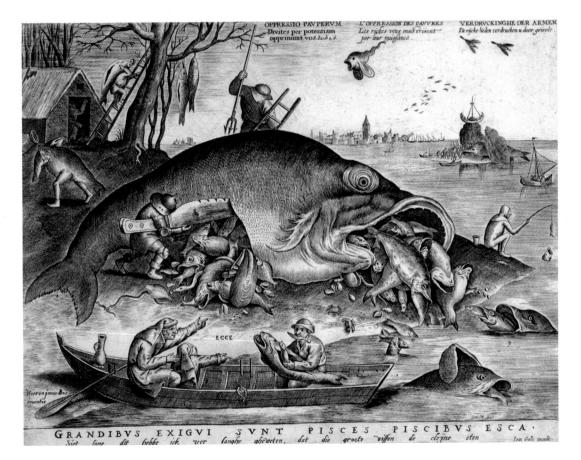

Within the engraving (as legible text):

Can any understand the spreadings of the Clouds the noise of his Tabernacle

15

Also by watering he wearieth the thick cloud He scattereth the bright cloud also it is turned about by his counsels

Of Behemoth he saith, He is the chief of the ways of God Of Leviathan he saith, He is King over all the Children of Pride

Behold now Behemoth which I made with thee

W Blake inventi & sculpt

London Published as the Act directs March 8, 1825 by Will Blake N³ Fountain Court Strand

LEFT

Illustrations of 'The Book of Job'
William Blake (1757–1827)
1826
British
Engraving
H 21.7 cm, W 17 cm

OPPOSITE

Drawing for the oil painting
*The Spiritual form of Nelson
guiding Leviathan*
William Blake (1757–1827)
c. 1805–9
British
Graphite
H 29 cm, W 26.4 cm

The Book of Job, describing the trials of a blameless man whom God puts to the test, includes some of the most remarkable poetic passages in the Bible. Books 40 and 41 describe two monsters of land and sea, the Behemoth and Leviathan, whose existence demonstrates God's power. The creatures have often been identified with the hippopotamus and the crocodile, which are reflected in the forms in William Blake's engraving. Blake, who was also a poet, seems to have identified with the long-suffering Job, whom God addresses at the top of the image.

The Leviathan appears in Blake's 'spiritual portrait' of Admiral Nelson, here represented by a study for the oil painting. The monster, embodying an apocalyptic vision of war, is guided not by God but by the naval commander. For sheer energy and violence, this extraordinary centrifugal composition is unsurpassed. It is one of two 'grand Apotheoses', the other an image of prime minister William Pitt with the Behemoth. Blake referred to Pitt as 'that Angel who, pleased to perform the Almighty's orders, rides on the whirlwind, directing the storms of war', which could also apply to Nelson.

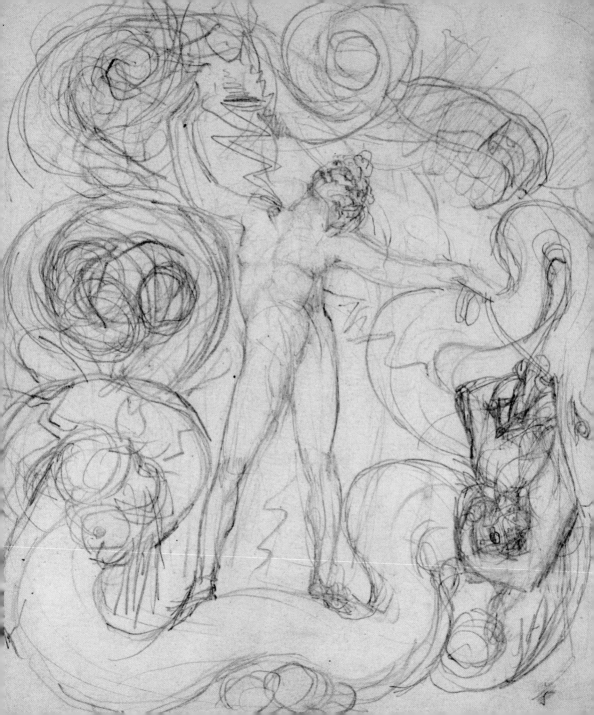

Further Reading

Sheila R. Canby, *Islamic Art close-up*, London, The British Museum Press, 2005

A.L. Dallapiccola, *Indian Art close-up*, London, The British Museum Press, 2007

J.D. Hill, ed., *Masterpieces of the British Museum,* London, The British Museum Press, 2009

Neil MacGregor, *A History of the World in 100 Objects*, London, Allen Lane, 2010

John Mack, *The Museum of the Mind*, London, The British Museum Press, 2003

Sonja Marzinzik, *Masterpieces: Early Medieval Art*, London, The British Museum Press, 2013

Jenny Newell, *Pacific Art in detail*, London, The British Museum Press, 2011

John Reeve, *Japanese Art close-up*, London, The British Museum Press, 2005

Kim Sloan, *A New World: England's First View of America*, London, The British Museum Press, 2007

Chris Spring, *African Art close-up*, London, The British Museum Press, 2009

Chris Spring, *African Textiles Today*, London, The British Museum Press, 2012

Nigel Strudwick, *Masterpieces of Ancient Egyptian Art*, London, The British Museum Press, 2006

Dyfri Williams, *Masterpieces of Classical Art*, London, The British Museum Press, 2009

Alison E. Wright, *Curious Beasts: Animal Prints from the British Museum*, London, The British Museum Press, 2013

List of Illustration References

Index

For Sophia, Clara, Emilia and my parents

I would like to thank my sister, Kate Masters, for her invaluable suggestions
and comments in the selection of images for this book.

I have also benefitted from the expertise of the British Museum's curators, and
thank Sara Forster at the Museum for making these liaisons so effective. The staff
of Thames & Hudson have been unfailingly perceptive and good-humoured, and I
would particularly thank Jen Moore, Maria Ranauro, Philip Watson and Julian Honer.

On the cover:
The items shown on the back cover can be found on the following pages:
(from left) 166, 27 and 90.

Bestiary: Animals in Art from the Ice Age to Our Age © 2018 The Trustees
of the British Museum/Thames & Hudson Ltd, London

Text © 2018 Thames & Hudson Ltd

Images © 2018 The Trustees of the British Museum

Designed by Peter Dawson and Alice Kennedy-Owen, gradedesign.com

First published in 2018 in the United States of America by Thames & Hudson Inc.,
500 Fifth Avenue, New York, New York 10110

www.thamesandhudsonusa.com

Library of Congress Control Number 2018932313

ISBN 978-0-500-48023-6

Manufactured in China by Imago

For more information about the Museum and its collection, please visit
britishmuseum.org